OUTCOME
LGBT Portraits

Tom Dingley

ARACHNE PRESS

First published in UK 2016 by Arachne Press
100 Grierson Road, London SE23 1NX
www.arachnepress.com
Outcome LGBT Portraits © 2016 Tom Dingley
Intoduction © 2016 Tom Dingley and Cherry Potts
ISBN: 978-1-909208-26-1
Edited by Cherry Potts
The moral rights of the authors have been asserted
All biographical content is copyright the respective contributors
All images © 2016 Tom Dingley

Printed in the UK by Short Run Press Ltd, Exeter.
Many thanks to Muireann Grealy for proof reading. Any remaining mistakes are me not reading her comments carefully enough. CP

This book was funded with the assistance of (among others)
Arachne Friends: Alison Maggs.
Crowdfunders: Kevin and Elaine Carey, Jonathan Blake and many who wished to remain anonymous.
What lovely people!

Introduction

No matter how hard it is growing up, no matter who you were, you become who you become, and you are amazing.

Tom Dingley and Cherry Potts on the Outcome Project

Tom:

Outcome is a photographic project that showcases portraits of gay, lesbian, bi and transgender (LGBT) people from a variety of different professions and with a variety of different passions.

Each portrait includes a printed photograph, chosen by the participants, of themselves as a child, to demonstrate their growth from the child they once were, to the adult they became after their experience of coming out.

Outcome portraits celebrate the 'outcome' of growing up, coming out and living your life. There are myriad opportunities out there no matter who you are or where you have come from – there is no need for sexuality or gender to hold you back. Outcome also celebrates the diverse roles LGBT people fulfil, and so provide young LGBT people with role models for life beyond adolescent angst, uncertainty and bullying. The portraits show that LGBT people are represented in all aspects of everyday life. This helps challenge stereotypes and broadens people's understanding of what LGBT people look like: there is no absolute definition.

The first photograph I took was of Gregory Gaige and this is the first portrait in the book. After that, I put out a call on social media for more subjects, and once I had enough pictures, I started exhibiting, firstly in group shows and eventually in solo shows at London Pride, Brighton Pride, Student Pride, Digital Pride and as part of Lewisham Council's LGBT History Month celebrations in both 2015 and 2016. Gradually the project grew, attracting activists and role models, and people who just liked the idea – which is how you got involved.

Cherry:
I came across the call out, and got in touch. Even before I met you, there was a little thought burning away, that this could be a book. My photoshoot took forever because I kept asking you questions and making suggestions – people to contact, exhibition spaces to explore. I kept sending you emails with more ideas, because I thought this is was an important and valuable project, as well as being rather beautiful, and I wanted to help it spread wide and far, but I still wasn't using the B word, worrying about the costs of colour printing as we'd only done black and white texts before.

Tom:
Exhibitions are bulky, time-consuming and short-lived. The online project is fine, but you do have to know to look for it.

Cherry:
And the best way I know to reach people is via a book. So I finally bit the bullet, and offered you a contract, but with a load of provisos, the crowdfund for instance, and I wanted a balance of male and female representation, including transgender people and a range of cultures, ages and (dis)abilities. I also said that whilst it was nice to have 'names' I thought it should be a book of celebration, not celebrity, and we should have as diverse a collection of professions and trades (or none!) as possible. The LGBT community live next door to you, they work with you. And here we are!

Getting There

Tom: The number of portraits built up gradually – with the help of pop-up studio days at different locations. All the shoots for Outcome were memorable, but some stand out more than others. For example, the time I escorted La Voix, in full drag, to my studio through a busy Greenwich before she performed at the Greenwich Street Party. Or Phil Ingud, the 'boylesque' performer, bringing his giant feather fans, and a pop-up studio day in Brighton and all the connections made from that – thanks to Lola Lasagne.

I have met so many role models and fellow equality campaigners along the way; it is such a rewarding experience. I am thankful for the opportunities and experiences: visiting bars, Pride events, people's homes, offices and even Parliament, to get portraits done. Sometimes I've had a great set up, in a big space combining the studio with an exhibition as I did at Student Pride, but sometimes I've had to squeeze into very small spaces and using whatever lighting was available. I have a mobile studio – lights, background sheet and frame, tripod and camera – that just fits into a really big kit bag, which gets hauled on public transport all over London and beyond. I encourage people to bring the genuine tools of their trade (those feather fans!) but sometimes the crucial prop is spontaneous: Peter Tatchell's portrait, for example, was finished off nicely with the addition of the megaphone, which just happened to be tucked into the corner of his room when the portrait was set up, or Tonnie Baakenist, photographed in Cherry's house, settling down at the piano.

Everyone has a story to tell – even those who think their life is not very exciting or full of drama; it's important to share the times that 'coming out' is not an experience to fear. Some people's stories though, are challenging and I have photographed some people without a childhood photo because they do not identify with the youngster they once were – or even because running away from home was their only option, and no photos made it out – but the important thing is that life got better for them and being part of Outcome is important to them, to show that you grow past that stage and become someone, your own person, making your own friends and family along the way. We are all individuals in a diverse LGBT community and need to be there for each other if times are hard.

Cherry:
That's why I wanted to do a book. It was fantastic, the support we got through the crowdfund to raise the money to produce the book, all those people saying *great idea, go for it, I'll help!* I think we all owe it to each other to stand up and say, *well, look at me, I'm doing ok.*

We had quite different reactions to the recent murders in Orlando – you were on social media talking yourself through whether it was frivolous or even irresponsible to do the book, to the point you were sure again, my immediate response was, *this is even more important now.*

**Beyond the book – launch, travelling exhibition and
slide show for schools**

The launch exhibition is at Greenwich University 10th-16th October 2016
with as many of the portraits as possible, printed at A2 size, so roughly
life-sized for the ones that aren't full length. We want people to really
meet our subjects 'eye to eye'.

We plan to expand the launch exhibition into a travelling exhibition
to visit colleges, schools, libraries, museums and community centres, and
anyone else who'll have us, around the UK, setting up a studio day at
each location to add to the portfolio. Keep an eye on the Arachne Press
website for dates so you can come and see the exhibition, and maybe
have your photo taken and be on the wall in a later one.

We have also created a slideshow version, which we hope schools
and colleges will use for Sociology courses and the like. If you are a
school or college and would like to purchase a copy of this get in touch.

Grow up – come out – live life – be who you are.

OUTCOME
LGBT Portraits

Tom Dingley

Gregory Gaige
Model, Disney employee

It's so important to spread the message that life does get better. We all have our own insecurities when we're young, but it isn't until we understand what they mean that we can embrace them as securities. Coming out was a struggle, I'd been bullied in school and at home my parents didn't really get it. So I told myself that it was only temporary. That got me through.

I'd just started work at the Disney Store when this portrait was taken (which was a magical dream), and now I've got a real career going, I've moved in with my boyfriend and best friend from high school; but most importantly I've grown into myself. I'm still the awkward geek from school, and that's okay, because I like me just the way I am – surrounded by Mickey Mouse plush.

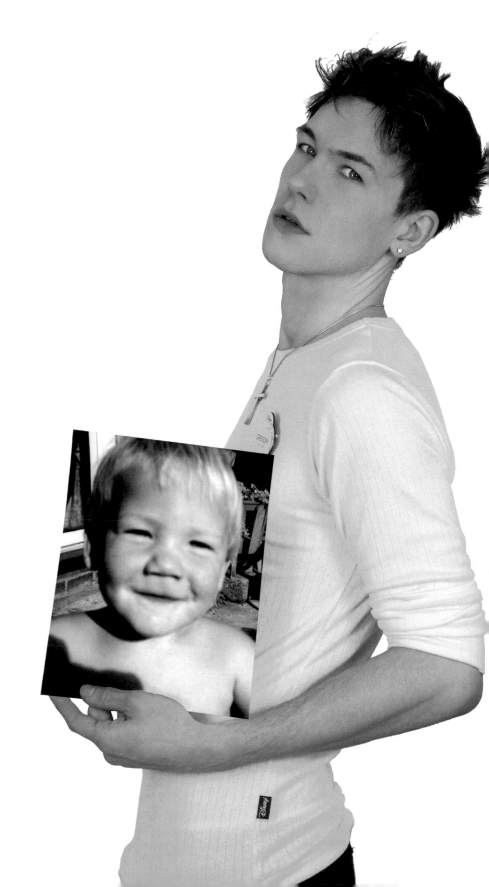

Alicya Eyo
Actress

Originally from Liverpool, I've been working in the acting industry for almost 20 years now (showing my age there!) and I love it! I went to The Courtyard Theatre Training School in Kings Cross and was lucky enough to get my first job soon after leaving, at the Royal Court, from then I've never looked back.

Various telly credits include *Band of Gold, Urban Gothic, Casualty, Waterloo Road, Holby, Silent Witness, Moving On, The Bill, Bad Girls* and (most recently) *Emmerdale*.

It's an honour to be involved in this project and I hope it reaches out and gives a positive message to all who read it.

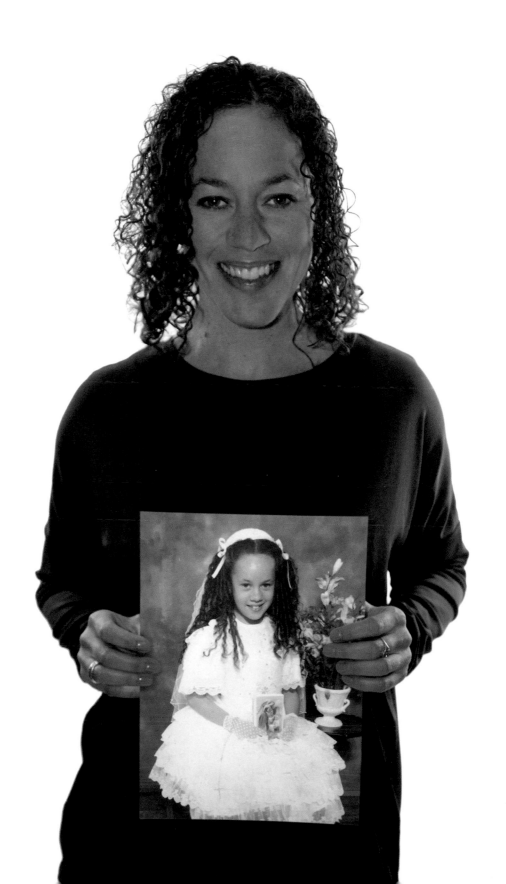

Ross Williams

Dancer

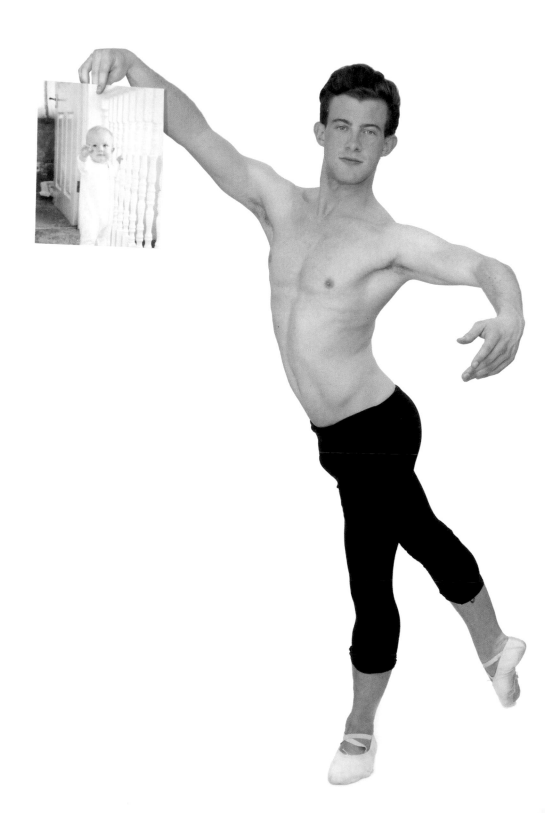

Bex Smith
Manager, *She Bar* Soho

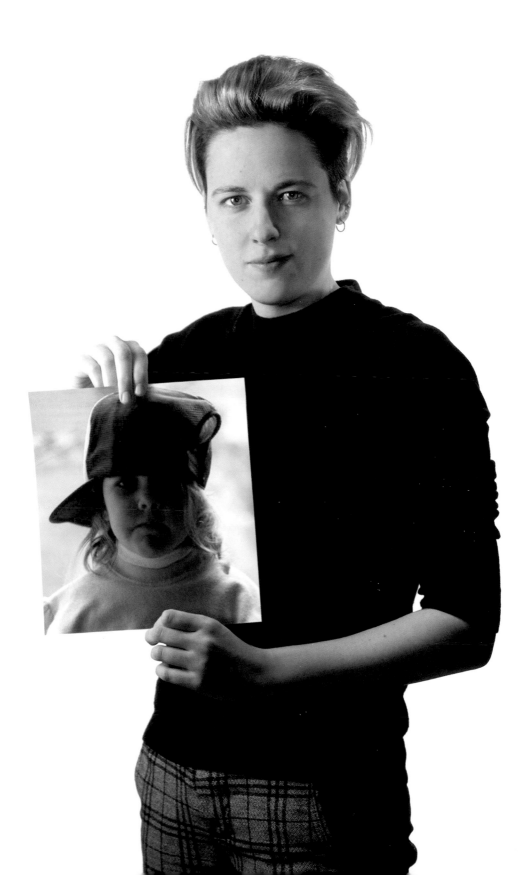

Stephen McKenna
Photographer

Stephen McKenna likes to declare himself as living proof that it's never too late.

Turning forty he sailed away from his career as a broadcaster and found himself bound for new shores to conquer a diversity of disciplines including photography, filmmaking, journalism and activism. Not to forget the straight marriage he was leaving behind.

'Despite being with a perfect partner', he reflects, 'I had to accept that I was suffering a form of atrophy as I suppressed my gay identity. I realised I couldn't make the other person in my life happy when I wasn't happy myself.'

Coming out for him was truly a re-birth and a number of years later he distilled his experiences into the website latelygay.com which has since become an indispensable 'go to' point for men opening up to their true sexuality in their later years.

As Stephen sums up, 'today I can look at the little boy in the picture of my younger self and know that his sense of anticipation and excitement was justified. That, small or large, our dreams can come through.'

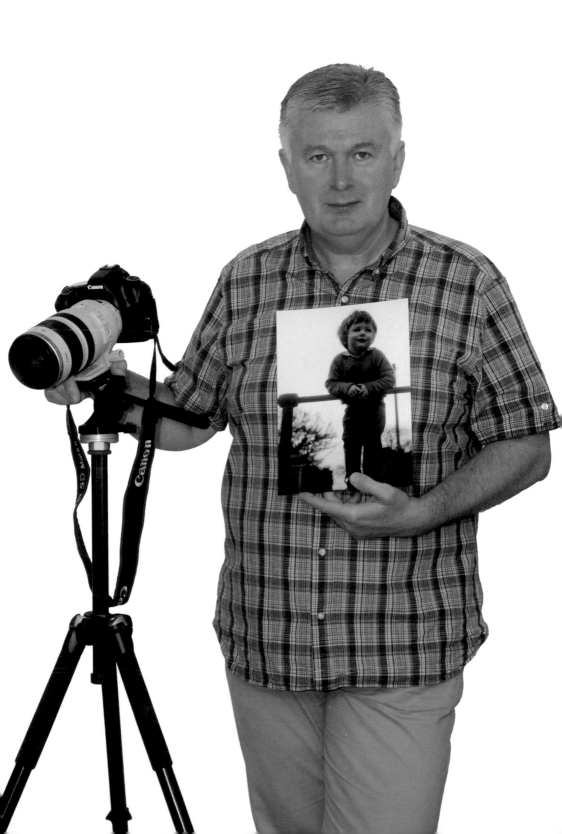

Hatti Smart
Student Pride co-chair

Coming out and growing up for me wasn't always the easiest of things but having moved to London for university and with the support of my amazing mom I feel like I can finally be an out lesbian and proud. London, for me, opened up a lot of opportunities such as working with National Student Pride as the co-chair, putting on an annual event and tackling taboo topics such as the stigmas around mental health and coming out. It makes me feel really proud to be part of what is the first pride event that many students and young people attend.

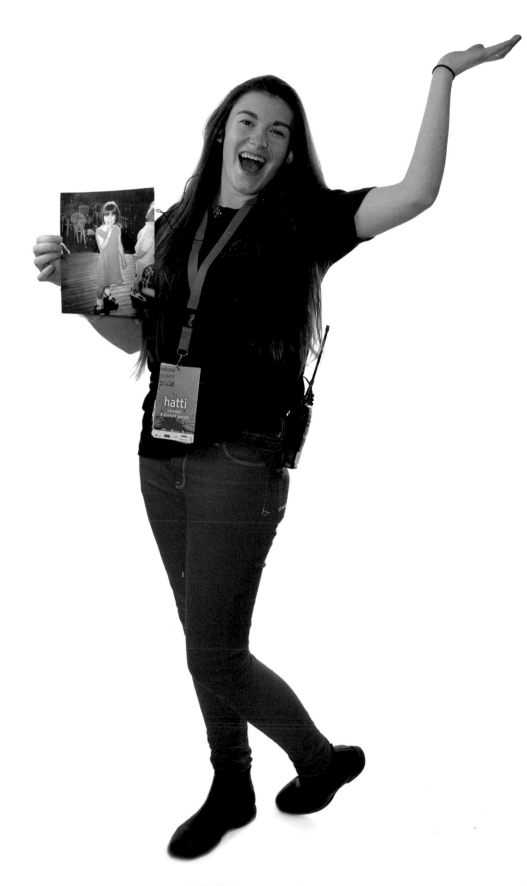

Dean Atta
Poet

Dean's debut poetry collection *I Am Nobody's Nigger* was shortlisted for the Polari First Book Prize. Dean was named one of the most influential LGBT people in the UK by the Independent on Sunday Pink List and featured in the Out News Global Pride Power List.

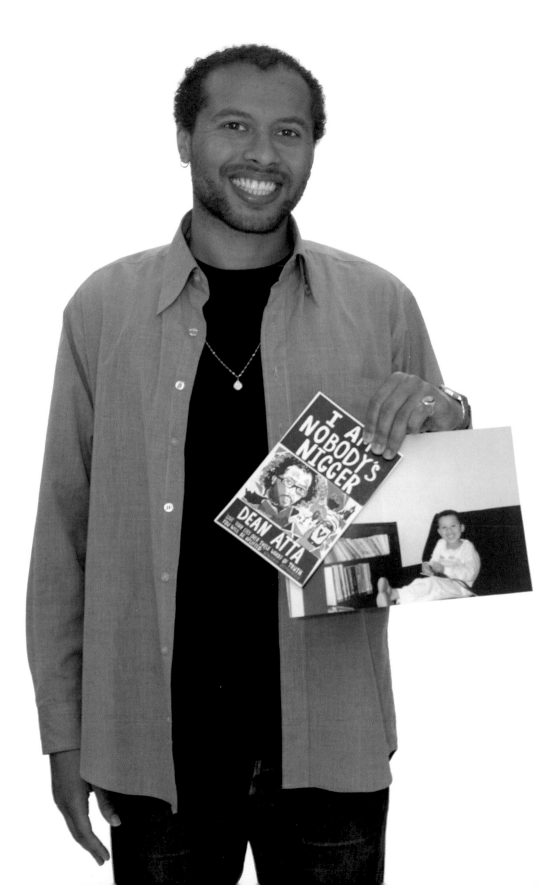

Nienke Westdijk
Financial Services Advisor

Phil InGud (Phillip Anthony)
Burlesque and cabaret performer

Phil has been performing as a male burlesque artist for 4 years now. Prior to this Phil performed for sixteen years, and was in the West End Production of *Chicago, The Musical*. He had a stint in *Dirty Dancing, the Musical* in Germany and most notably, performed in *Mamma Mia! The Movie*.

Phil is delighted to be involved in the Outcome project.
Just remember: you can be whatever you want to be, as long as you believe in who you are.

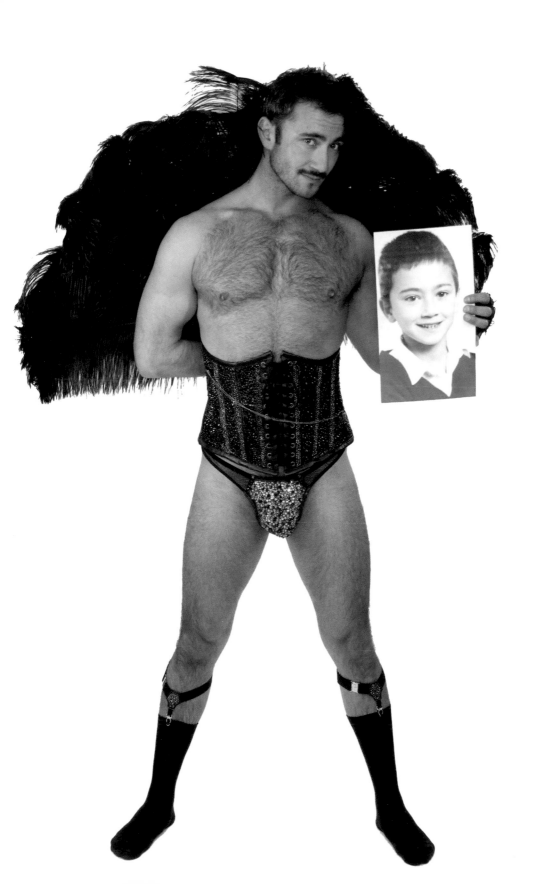

Melantha Chittenden
National Union of Students LGBT+ Officer (Women's Place)

I've just left university where I was studying conflict, peace and security and I'm on the NUS LGBT+ committee. I've been out to my friends since I was sixteen and I'm not out to my parents yet. I'm a bisexual woman.

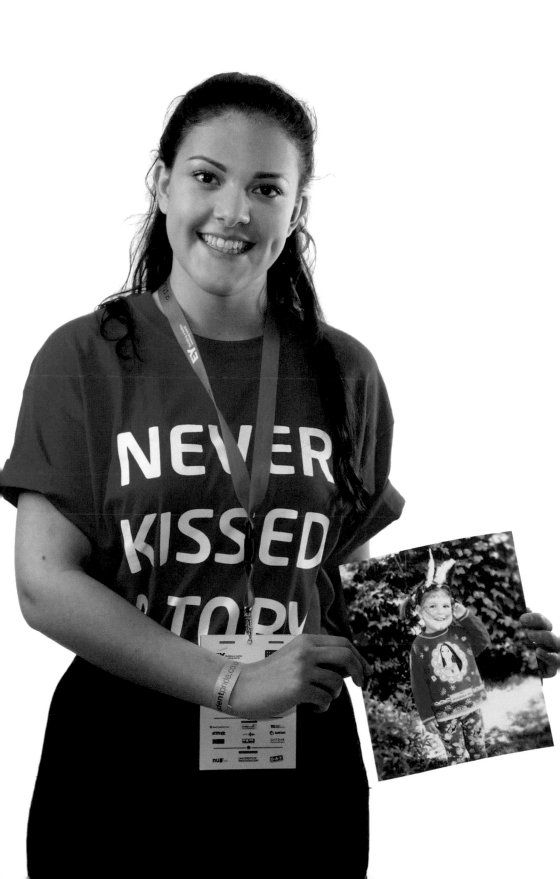

Kevin Wilson
Student Union officer at University of the West of England

As a black individual who grew up in a society that labels homosexuality as an illegal act, I grew up there being bullied and learned to be strong enough to look at a bigger picture.

I came to England for a two-week holiday and almost twenty years later I'm still here (legally of course).

All I can say to that young gay person who is or has gone through oppression is that it'll be long, but not forever.

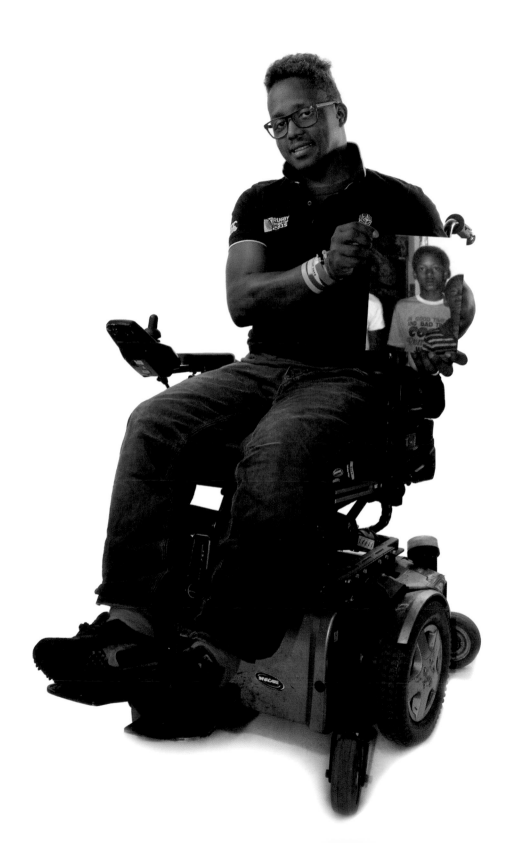

Kalie Jade
Medium and sound healing practitioner

Everyone has a coming out story, some more painful than others, but with each Gay Pride we come together to celebrate our journey. We express ourselves through colour, creativity and passion – and peaceful protest to mark the struggles that came before us.

In the UK we are blessed to live in a place where it is largely acceptable to be our true selves, without hiding behind a mask. #Outcome is a beautiful project that reminds us all to follow our dreams and stay true to who we really are. I personally believe that we can achieve anything in this lifetime, if we trust and believe. The first step is knowing what you want, from here plant the seed and watch it grow...

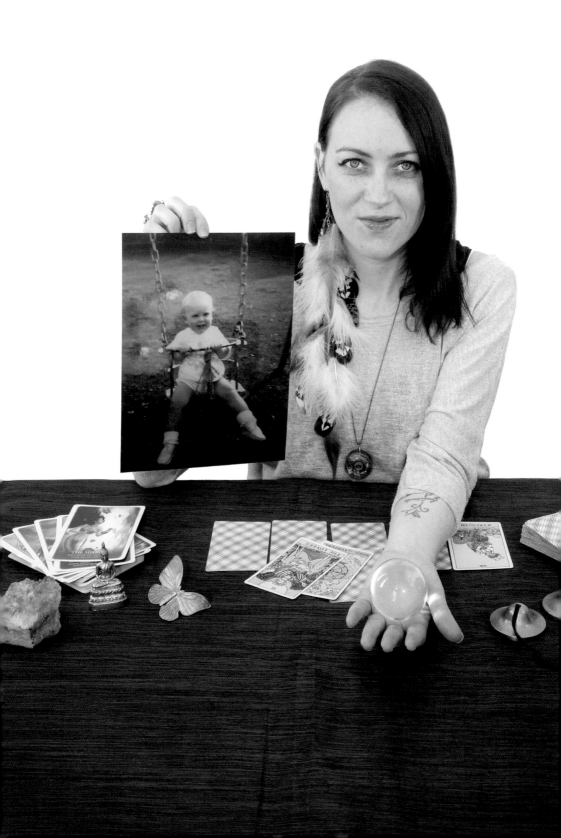

Alistair Frederick
Theatre Actor, Producer, Writer, Singer

Alistair is a 27-year-old actor from Liverpool who has worked on a number of projects around the world. Most recent credits include; singing for Disney, playing Mercutio in *Romeo and Juliet* and Understudying the lead role in *Rent: The Musical*, London.

In 2016 Alistair will be writing and producing some exciting new productions in London. Watch this space...

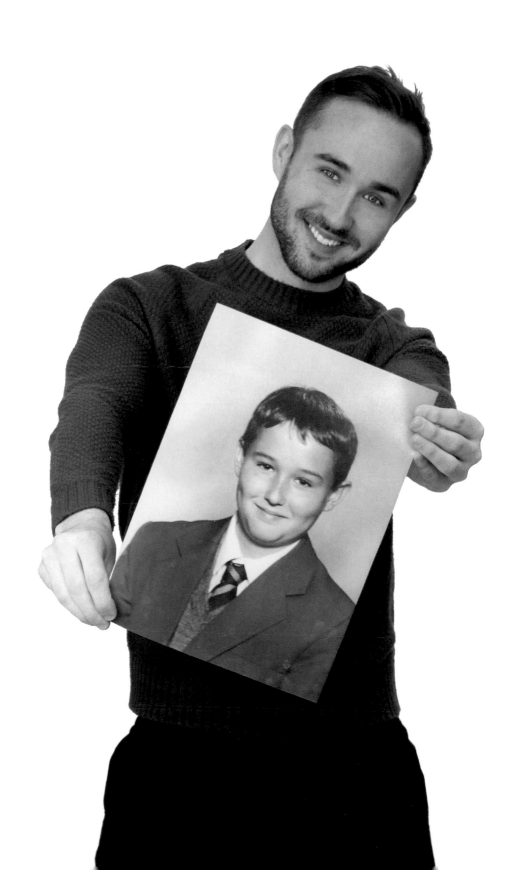

Tonnie Bakkenist
Conservator

Tonnie was born in 1946 and grew up in a loving family in Amsterdam. Both facts made it easy to come out, especially because her parents had gay friends and Amsterdam had at that time not only the COC but also women only cafés.

She studied and did her doctorate in biochemistry at the University of Amsterdam. After years of biochemical research she got involved in the science of conservation. Scientists go regularly to conferences, one conference turned out to be very important as she met Kate Foley there. And the rest is history. Tonnie sometimes plays piano at Kate's poetry readings.

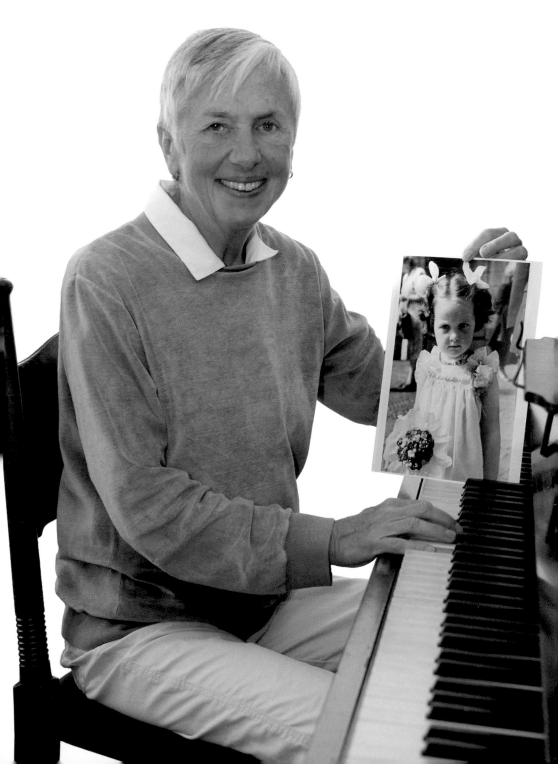

Chris Smith (Lord Smith of Finsbury)
Member of the House of Lords

Former Member of Parliament and Secretary of State for Culture, Media and Sport. First out MP (1984), and first out Cabinet Member in the world.

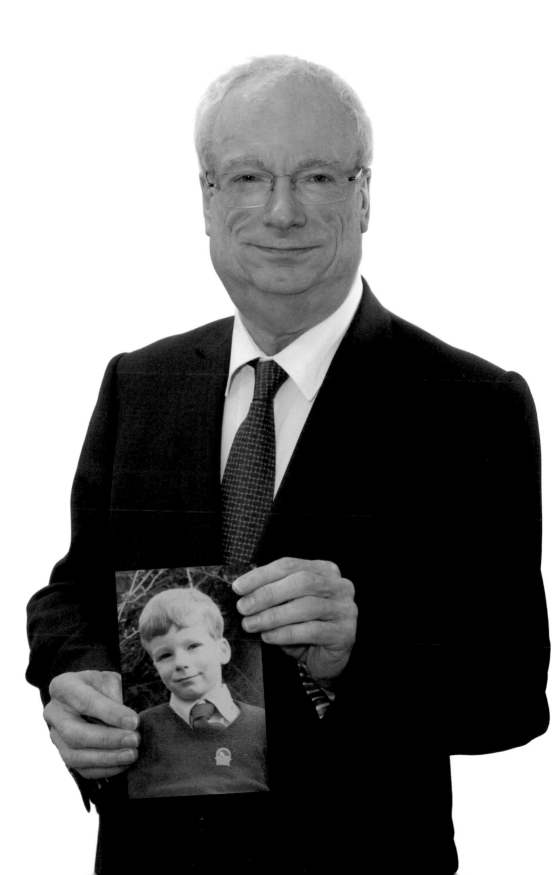

Sage Barrier
Film student

I never really came out. It was more a side thing. Like, telling people your star sign.
Person: 'What are you?'
Me: 'Oh I'm Pansexual Virgo.'
People were only interested in the five minutes we talked about it. It was a completely normal and mundane topic. Growing up in Los Angeles added to the normality of my sexuality. No-one really made me feel bad or ashamed. It breaks my heart when I hear other's stories in the LGBT+ community about growing up the exact opposite of me. Being judged at a (for most) young age for something that is completely normal. Sexuality/gender should be as normal as stating your favourite colour, or your favourite food. It's 2016 for fuck's sake.

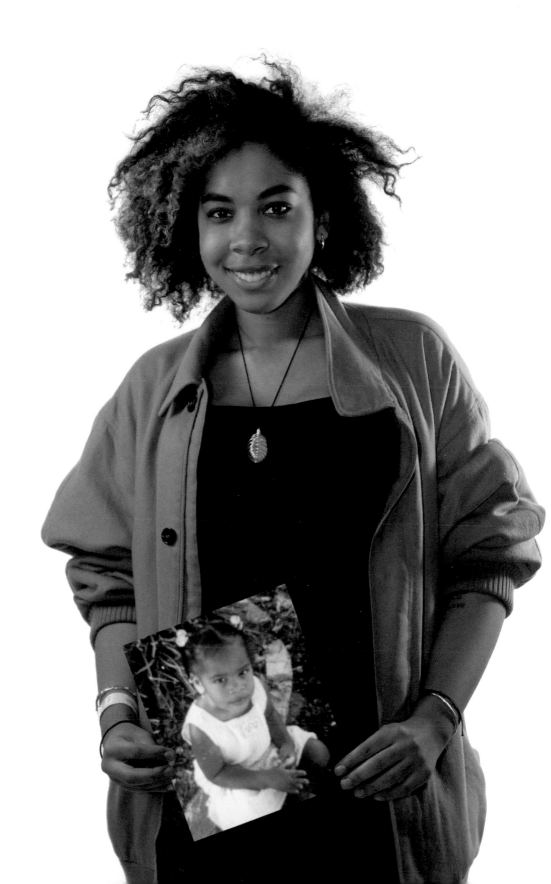

John Whaite
Food writer

John studied at Le Cordon Bleu, though his love of food came from learning at his mother's knee. He writes for the *Telegraph* and is resident chef on ITV's *Lorraine*.

Food has always been John's passion. He grew up on a dairy farm where he learned about British produce and the importance of supporting local food producers and artisan crafters. His parents also owned a fish and chip shop, where John started his first job – as potato peeler – at just ten. Even earlier than that, he was always keen to make a living from food, selling bags of pick and mix to his peers at school – without the teachers knowing, of course.

Gaining a first class degree in Law from the University of Manchester after declining a place to study at Oxford University, John decided to hang up the gown and don the apron, a decision spurred on after he won the third series of the BBC's *The Great British Bake Off*.

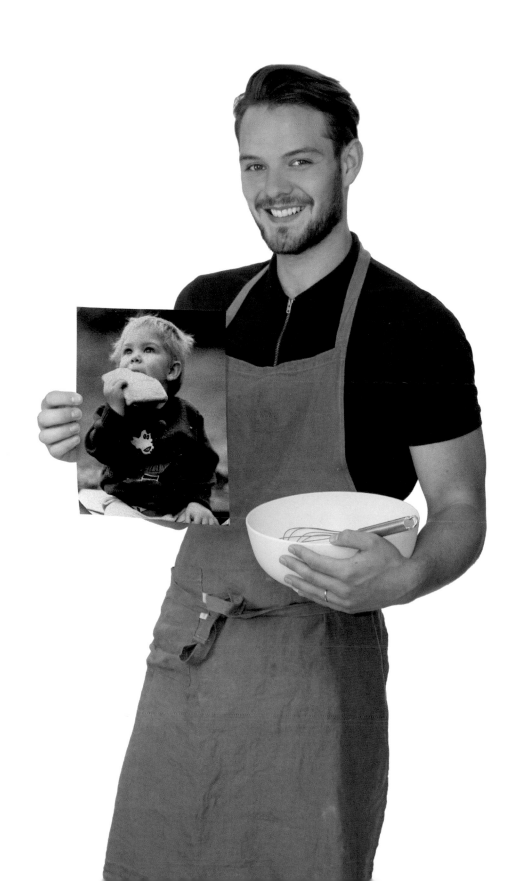

Hannah Winterbourne
British Army officer and trans advocate
Jake Graf
Writer, director, actor and trans advocate

Captain Hannah Winterbourne has been in the British Army as an openly transgender woman since 2013. She took on the role of Transgender Representative for the Army which includes promoting diversity in the forces, advising on policy, educating hierarchy and mentoring other transgender soldiers. Outside of the Army she is patron of the charity Mermaids and Ambassador for LGBT Sport in Wales.

Jake is a writer and director based in London, whose first four films, *XWHY*, *Brace*, *Chance,* and *Dawn* have all been nominated for the prestigious Iris Prize. Touching on topics from homophobia, hate crime, asylum seekers, domestic violence and disability, they have gone on to win numerous Best Short and Audience and Jury favourite awards.
His first Youtube video, *What It's Like Being Transgender* reached 400K views online, and he has this year written for GNI, QX and FTM Magazines, as well as Cosmopolitan online, and continues to be an active advocate for the trans community.

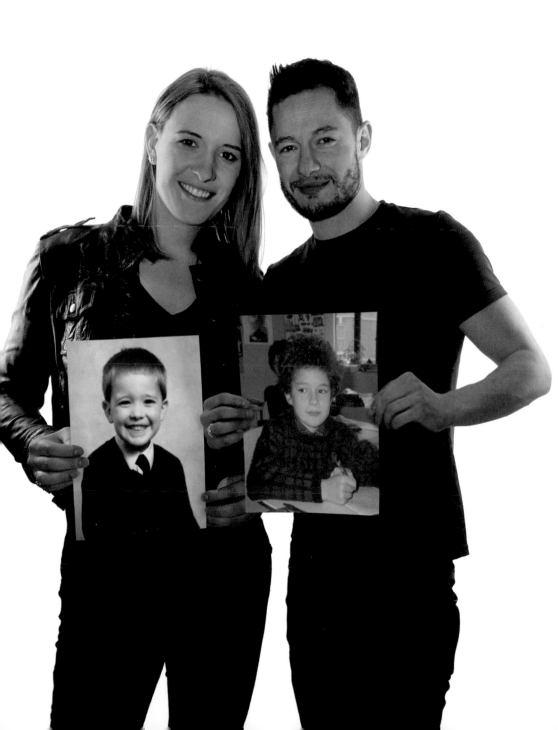

Sanjay Sood-Smith
Candidate on BBC's *The Apprentice* series 10.
Stonewall role model.

Sanjay Sood-Smith is best known as a Candidate on the 10th series of BBC's *The Apprentice* (2014), making it to the 10th week of the process. Taking part in *The Apprentice* inspired Sanjay to leave banking and to develop *Tuk In*, an Indian curry-in-a-naan microwave meal which is currently available on both Thomson and British Airways.

Sanjay volunteers with the charity *Stonewall*, acting as a 'school role model' where he talks to children about his experiences of homophobia and overcoming being bullied when he was younger for being different. He was recently shortlisted for the Positive LGBT Role Model award at the prestigious National Diversity Awards for his work on fighting homophobia with young people.

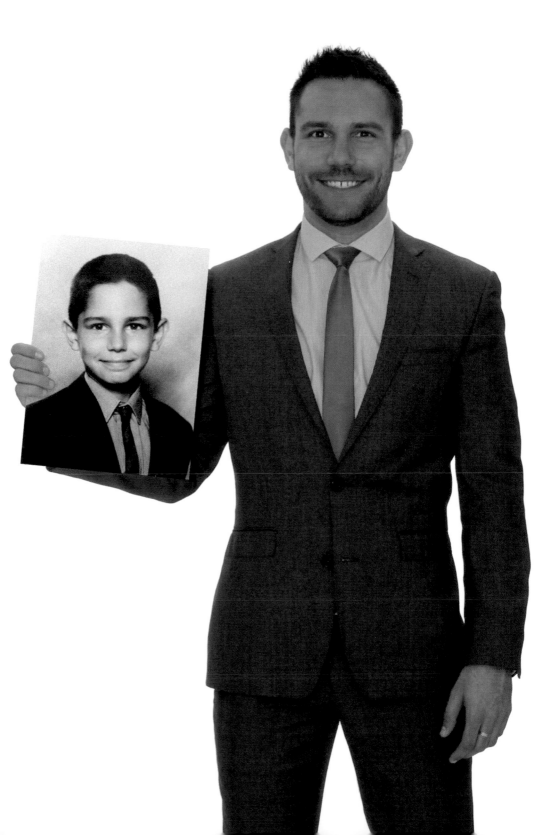

Libby Rose
Seamstress and sewing teacher on Pink Bus Project

A self-confessed 'shy' character, on hearing about Tom's Outcome project, I felt an overwhelming want to be a part of it. Tom's vision to show 'things get better' and to show, in particular to young people, that 'being gay does not need to dictate who you are.' Being gay is only one part of your make-up. I work with young people on a daily basis and they do not necessarily know or need to know if I am gay or not as this does not matter in what I am teaching them. I do watch the struggles they go through every day in different areas of life. What Tom is doing is so important to show that you can come out and actually it's more than ok to do so.

I know when I finally 'came out' not as a 'half/half', not as a 'sometimes' or 'depends who's asking', it was a life-affirming transformation and I only wish that I had the guts to do it earlier in life. We often get filled up with preconceptions that people will judge you or your social circle will be cut or the family wont accept you... Sadly this may be true in some cases but it should not hold you back in being yourself and having the freedom to live, strive and accomplish all you want in life as gay or straight or anything you want to be.

I feel so lucky every day that I can hold my head up and be 'proud to be gay' but also live in an equal society where it doesn't matter. I can do the job I want to do, I can live the life I want to, all as a gay woman. And for that I am proud and so thrilled to be a part of #outcome.

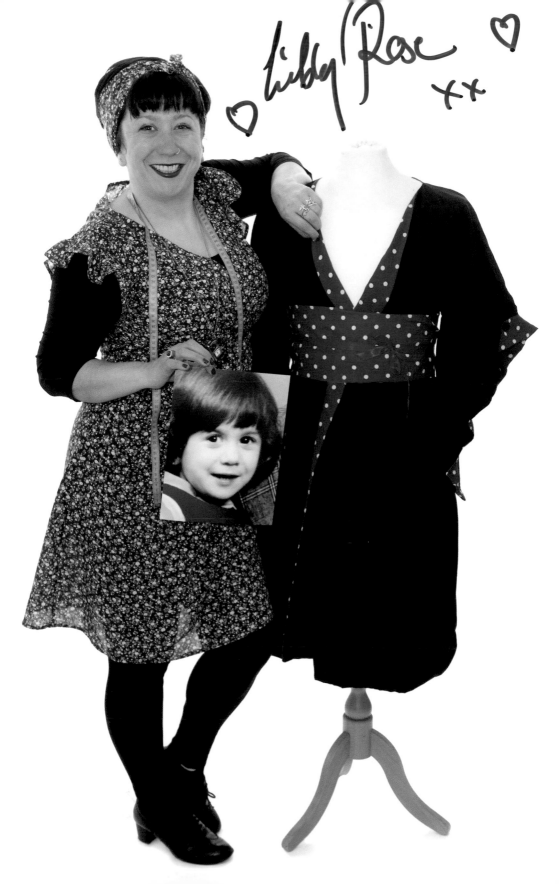

Libby Rose
xx

Wes Streeting
Labour Member of Parliament for Ilford North.

Elected in 2015, I'm one of a record number of openly LGBT MPs in what's been described as the 'gayest Parliament on earth'. I spent my career outside politics working for a number of charities focused on tackling educational disadvantage – including a stint as Head of Education at Stonewall, where led Stonewall's campaigns and programmes to tackling homophobic bullying in schools.

I came out when I was nineteen, at university. I went to an inner city comprehensive boys' school in London where homophobic bullying was pretty common. It wasn't until I went to university that I accepted that I was gay and felt able to tell my friends. Once I did I felt comfortable in my own skin: it was liberating.

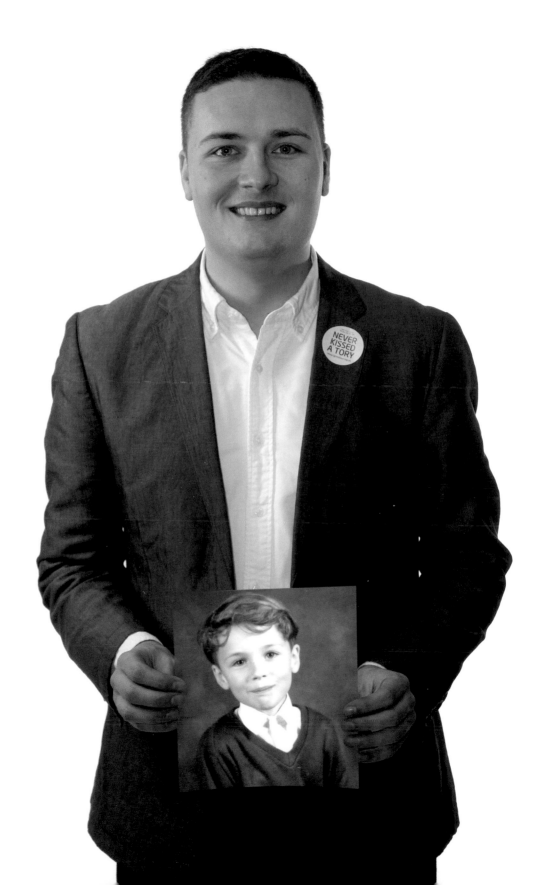

Veronica Fearon (V.A. Fearon)
Author of *The Girl with the Treasure Chest*

Coming out for me was something I did in instalments. Every time I told someone it got easier but once I told my mum all my anxiety fell away. I now find I want to tell everyone. I'm proud of who I am and the choices I've made.

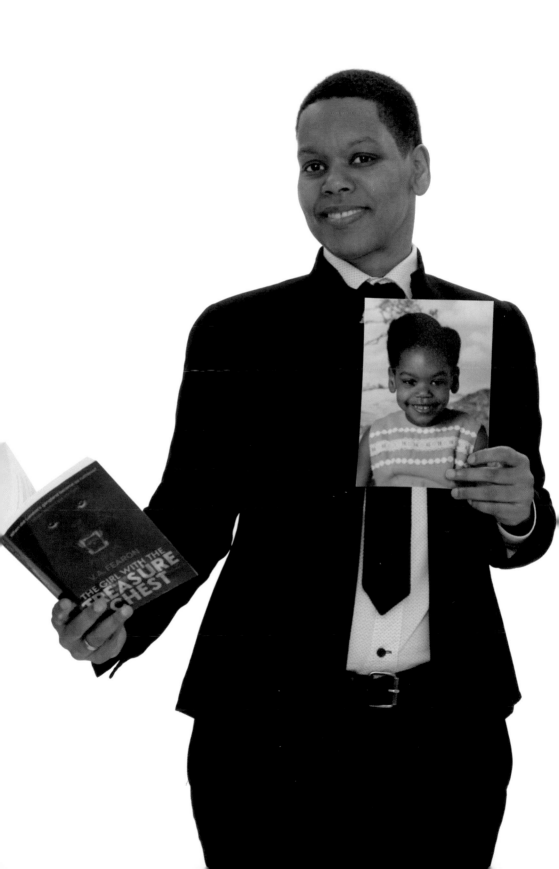

Roland West
YouTuber

My name is Roland, I'm twenty-five and living in London. I grew up in a small town in Devon until last year when I moved to London. I came out with I was sixteen. I work in retail but I am also a full time YouTuber and have been creating videos for the past five years. I identify as genderfluid and only really accepted that last year!

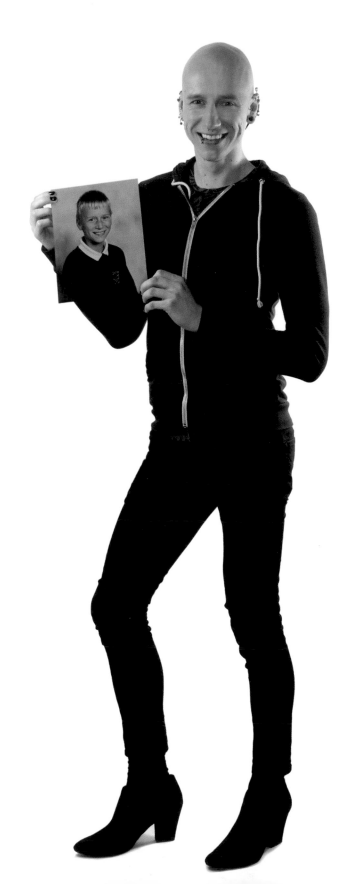

Anna McNay
Arts editor for *Diva* Magazine.

Anna McNay (b. 1979) is a freelance art writer and editor. She is deputy editor at State Media and arts editor at *DIVA* magazine. She contributes regularly to *Studio International, Photomonitor* and *The Mail on Sunday* and has been widely published in a variety of other print and online art and photography journals and newspapers. She has written numerous catalogue essays and regularly hosts in conversation events and artist talks.

Coming from a background in linguistics, as a postgraduate tutor and lecturer at the University of Oxford and research fellow at the Humboldt University in Berlin, McNay now specialises in art that deals with representations of the body, gender and sexuality. She also works with arts facilitation for mental health charities.

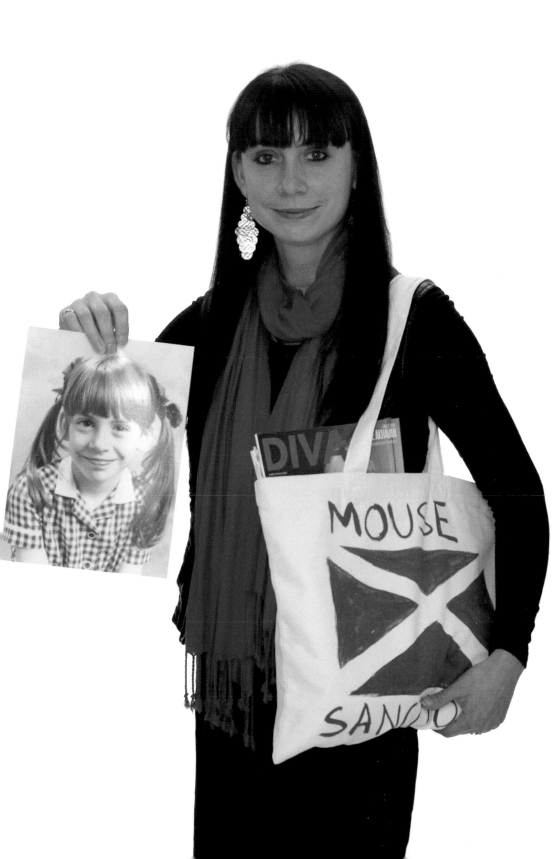

Randon Burns
Jujitsu practitioner

Randon has always been an enthusiastic supporter of gay athletics having participated in gay boxing, ballroom dancing, swimming, circus arts and pictured here – jujitsu, in which he achieved the rank of black belt. He also blogs about books with gay characters at goodgayread.com and runs his own company.

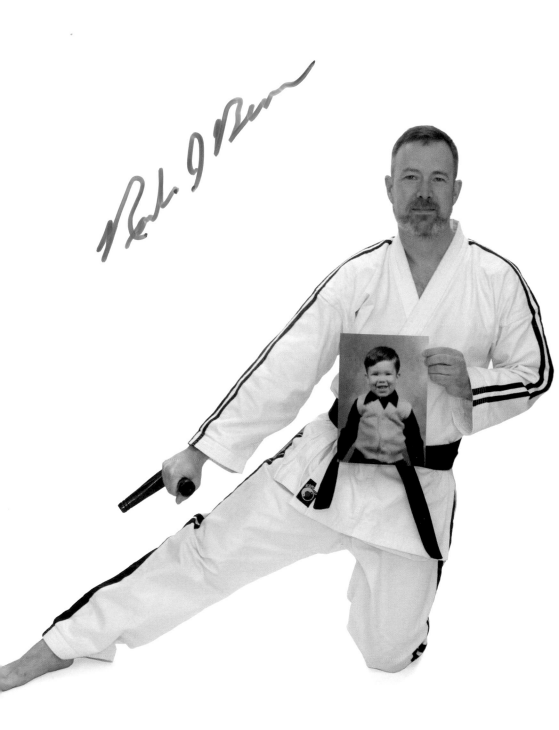

Hizze Fletcher King
Artist and curator in Brighton

Since graduating from Central St. Martin's in 1989 I have had a varied and extensive career in the creative industries working as a photographer, set designer, graphic designer, mosaic artist, art tutor and art director. Since moving to Brighton in 2006. I have collaborated with the creative community curating group-art shows and events, while helping to raise money for local and international charities. I'm a fine artist in my own right, selling and exhibiting in the UK and internationally. I have two children and have been with my partner, Jojo, for seven years, we married in 2014. That same year we opened our unique shop; BRUSH is a hair salon and art gallery in Brighton's North Laine.

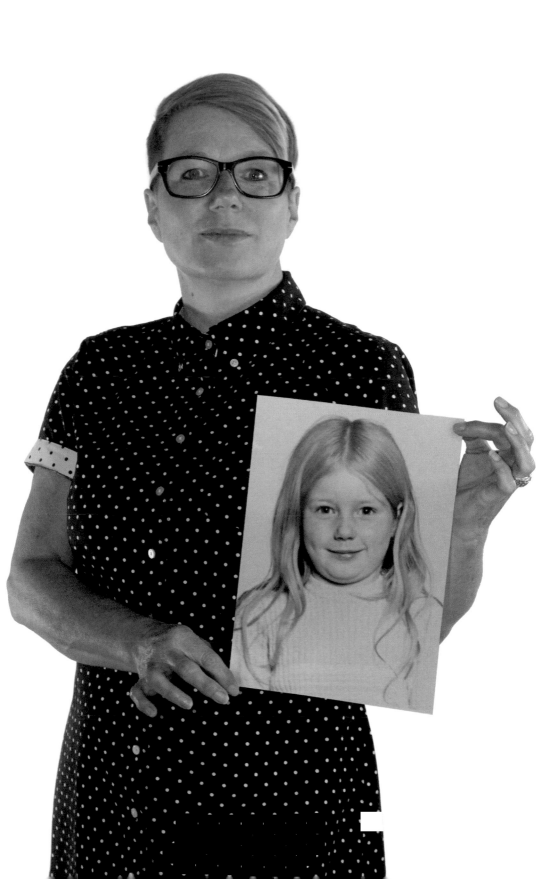

Fox Fisher
Artist, film-maker and campaigner

After taking part in Channel 4's *My Transsexual Summer*, Fox set up *My Genderation* with Lewis Hancox and made 50+ short films, including *Tayler* which won *BBC Fresh*. Fox also co-created eight short films on trans issues for the NHS.

Fox promotes trans matters through appearances on television. He is an advisor to *All About Trans*, creating *My Trans Story* with them for Channel 4. He has created 25 short films for Patchwork project and facilitated interactions with the BBC, *The Daily Mail*, *The Sun* and *The Observer*, to discuss representation in media.

As director of Lucky Tooth Films, Fox made Vicky Beeching's 'coming out' video, comedy *Heartichoke* and worked with Will Young on music video *Brave Man*, casting a trans lead.

Fox plays the role of Jake Greenleaf in Radio 4's adaptations of Armistead Maupin's *Tales of the City* (2016).

Fox co-created the Trans Acting course for Royal Central School of Speech and Drama, and is a script consultant for BBC *Eastenders*' trans character Kyle (2016).

He is patron of LGBT Switchboard, FTM Wales and 'Ties To Love', co-creator of the children's book: *Are You A Boy Or Are You A Girl?* and co-creator of Trans Pride Brighton. In 2014 he spoke at Tedx Brighton, and the University of Brighton made him a *Brighton Titan*. Fox is included in *The Independent*'s Rainbow List for his film and community work (2014-2016) and is listed on Huffington Post's '9 Inspirational Gay, Bisexual and Transgender Men Who Are Redefining Masculinity'.

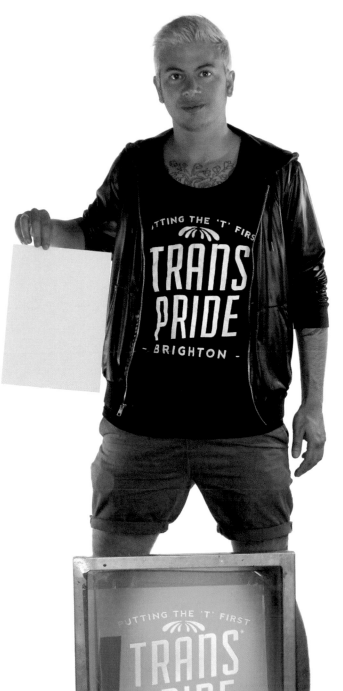

Akeilah Bennett
Co-Founder and CEO of A.Z Magazine
Electronic Engineer

I was asked several years ago, what I did to support the LGBT+ community apart from go to pride and attend the clubs. I had no answer... That question got my brain ticking and looking at what I could do to make this a better community for all that are in it. A.Z Magazine (also known as A.Z Mag) was created in 2015 as a result.

A.Z Magazine is a BME (Black and Minority Ethnic) LGBT+ online magazine that aims to be a platform allowing the voices of the marginalised BME group to be heard. It is a safe space for people to share their narrative and experiences.

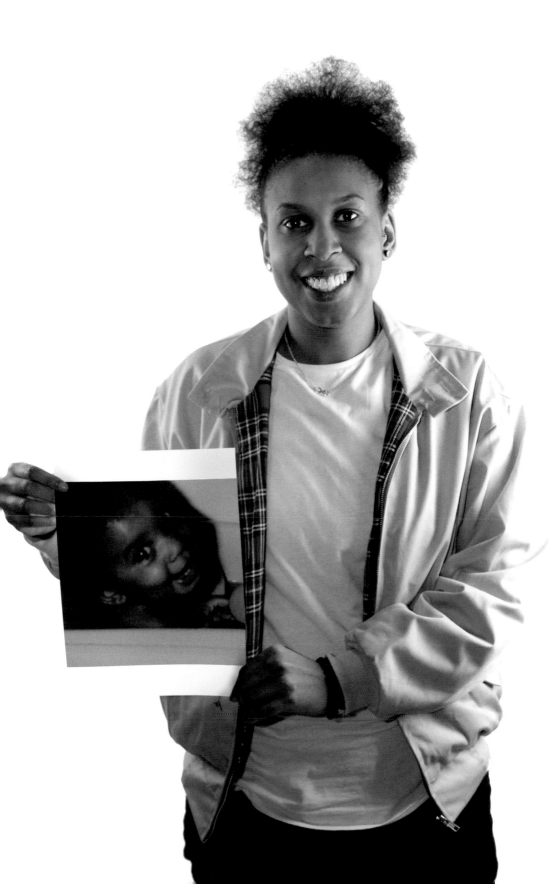

La Voix
Drag superstar

Multi-award winning and critically acclaimed, La Voix lives life on a single mission to bring back old school glamour.
La Voix has shared the stage with Mickey Rooney, Simon Cowell, Cilla Black, Pamela Anderson and Alan Carr, to name a few.
La Voix has been performing for the past ten years and has gained international cabaret acclaim.
Larger achievements include performing at the 02 Arena as Spandau Ballet's guest artist, semi-finalist on *Britain's Got Talent*, second place in *RuPaul's Drag Race UK Search*, London Cabaret Award winner and featuring as a cameo part in the *Ab Fab* movie.

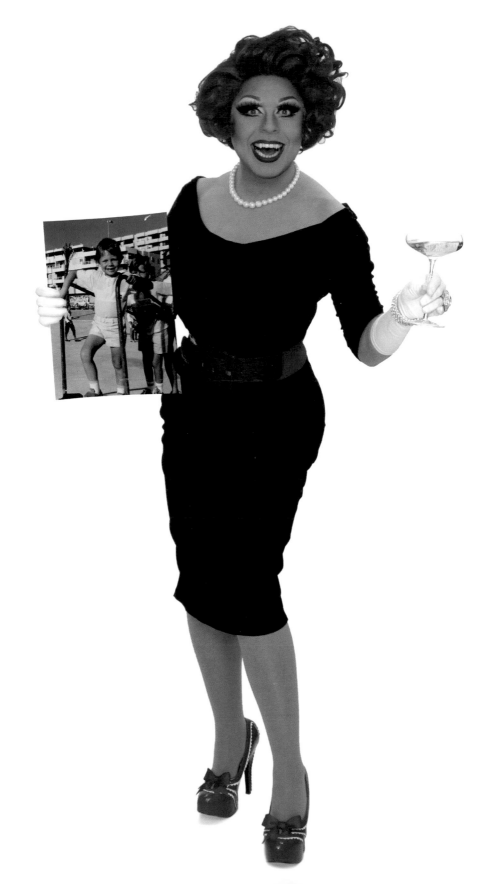

Tina Ledger
Promotions manager/DJ *She Bar* Soho.

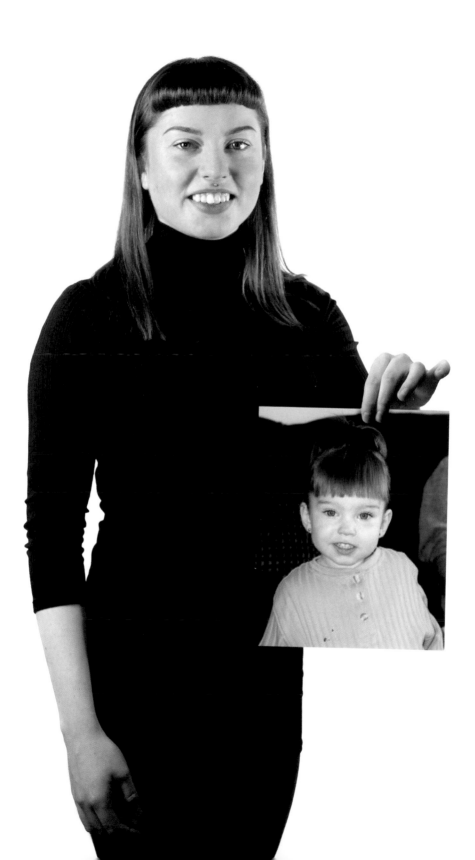

James Clark
Diplomat and businessman

I enjoyed a long and successful diplomatic career, including periods living and working in the US, Luxembourg (as UK ambassador), Germany, Belgium and Egypt, as well as in the UK. I left diplomacy in 2010 and began a second career running my own executive coaching and consultancy business. I'm now based near beautiful Bath, but still work around the world. It wasn't until about 1996 — when I was thirty-three — that I realised I was gay; so I had some catching up to do! My husband, Tony, and I have been together for seventeen years. I was the UK's first openly gay Ambassador; so Tony and I were the first gay diplomatic couple to have the traditional audience with The Queen — our short but proud moment in gay history.

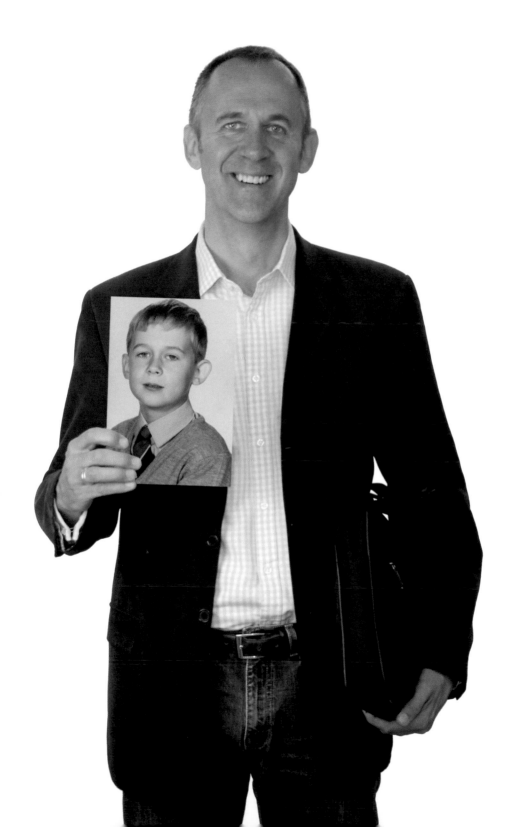

Alix Adams
Retired academic lawyer, writer, walker

Alix's introduction to her lesbian identity came via a massive crush on a gym teacher at her girl's school in the mid 1950s (her diary for 1956 makes for eyebrow-raising reading). This turned out to be a phase that never wore off, although reading *The Well of Loneliness* at an impressionable age put her off as she didn't relate to wearing men's underwear.

Marriage and three children, and a career teaching law, hid her from herself for seventeen years, then in the early 1980s she went to a women's studies group and the penny finally dropped.

She came out properly via the Sappho married lesbian's group, met Cherry Potts (at that women's studies group) and has lived with her ever since. Alix has written a successful law text book now in its ninth edition. Now in her 70s she sings in community choirs and operas and walks regularly tackling long-distance paths in ten-mile segments — when she isn't falling over.

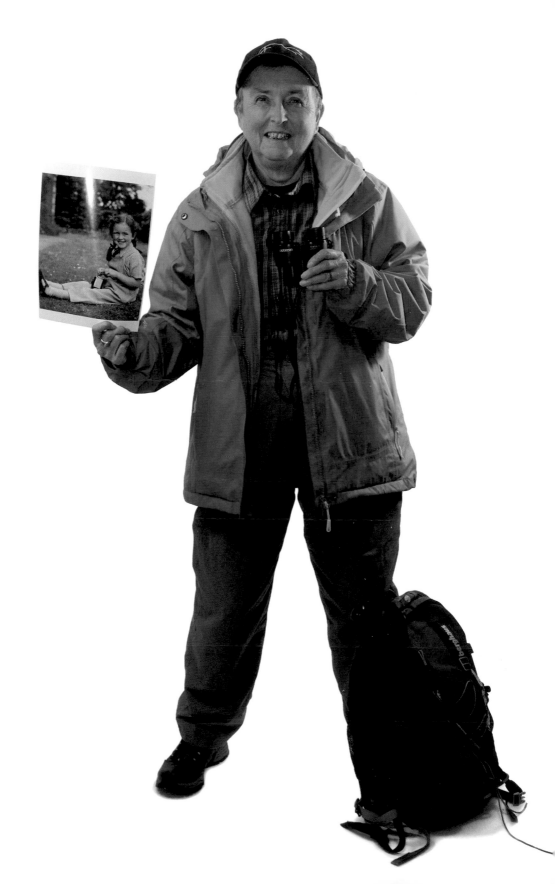

Tom Dolphin
Doctor and trade unionist

I grew up in a small town in Essex and went to an all-boys school. The school tried to show pupils that it was okay to be gay, an approach which wasn't common in the 90s, but I didn't feel I could come out to anyone until after I left.

At medical school in London, aged eighteen, I found that being gay was no big deal. I was warned by a couple of kindly intentioned senior doctors that it might hold me back in my career, but their concern was rooted in a more repressive past. Besides, what was I going to do: hide it forever?

By being myself and being straightforward, I found people generally took a live-and-let-live approach of uninterest in whom I loved. That makes it sound easy, but there was a lot of culturally ingrained internalised homophobia I had to get over to be relaxed about it myself. Even now I still feel anxious holding hands with my partner in public in London; I don't think that will ever go away entirely.

My peers at medical school elected me student president, an experience that was transformative. Being surrounded by out-and-proud LGBT people getting on with their jobs gave me new confidence. I stayed involved with medical politics after graduation, eventually becoming one of what the media call 'doctors' leaders' with a national role at the BMA. Gay men are actually disproportionately present in medical politics, just as in student politics, and this is no bad thing.

I feel strongly that standing up for others who are being oppressed or exploited gives strength to our own demands for equality as LGBT people, and I certainly aim to challenge racism, sexism, transphobia and other manifestations of bigotry wherever I encounter them, although sometimes this is easier to say than to do.

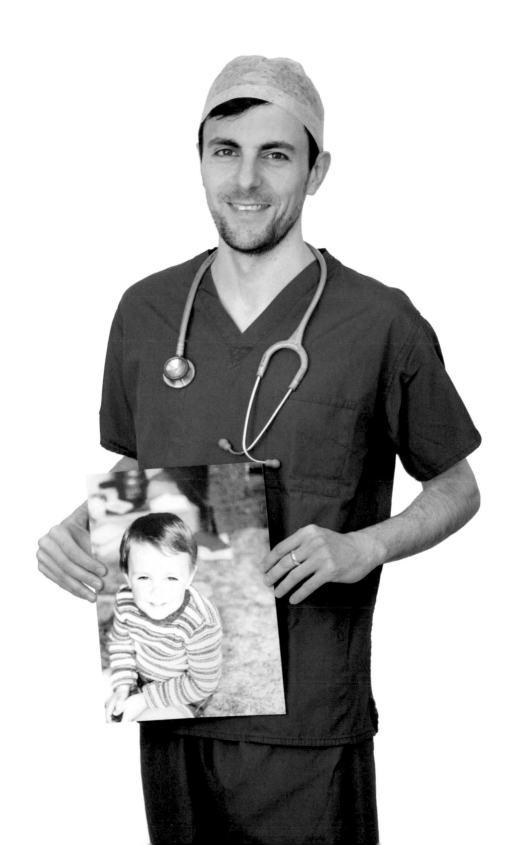

Vanessa Pope
Director, researcher, PhD student

Following an education in psychology, theatre directing, cabaret management, and dive bars, Vanessa is now a PhD candidate researching the performing arts through tech.
As co-founder and member of The Effort Collective, Vanessa directs performances, plays and installations, and curates events and exhibitions. Her lesbian identity and queer politics continue to inform her artistic and academic output, as well as her boudoir.
Vanessa grew up and came out in Istanbul and is now based in London.

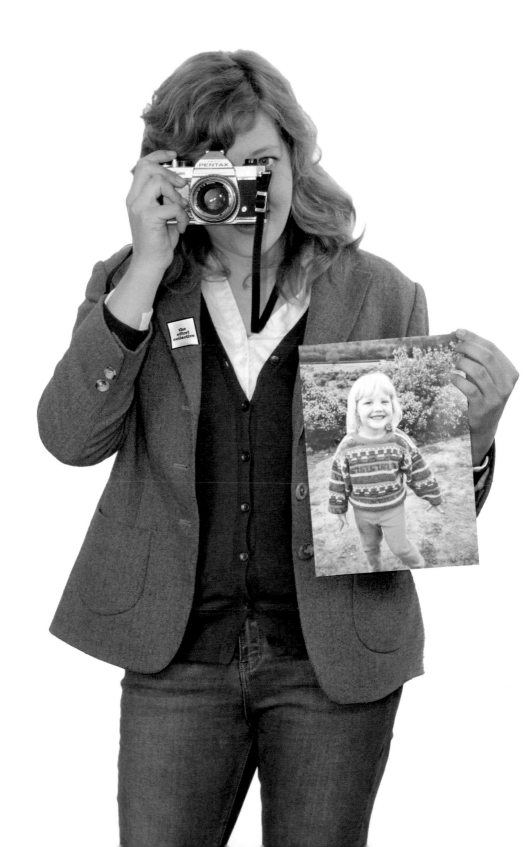

Jay Kamiraz
Pride of Britain 2012 award winner

Jay Kamiraz aka Mr Fabulous is a London-based entertainment creative, ambassador and sassy radio advisor on BBC Asian Network. Best known for his inspirational story, carrying the Olympic Torch and winning the prestigious *Daily Mirror* Prince's Trust Pride of Britain Award, awarded by HRH The Prince of Wales and Pierce Brosnan.

He touched the nation appearing on Channel 4's *First Dates* which won a Bafta and continues to build his profile in television radio and entertainment.

He can be followed on twitter @jaykamiraz

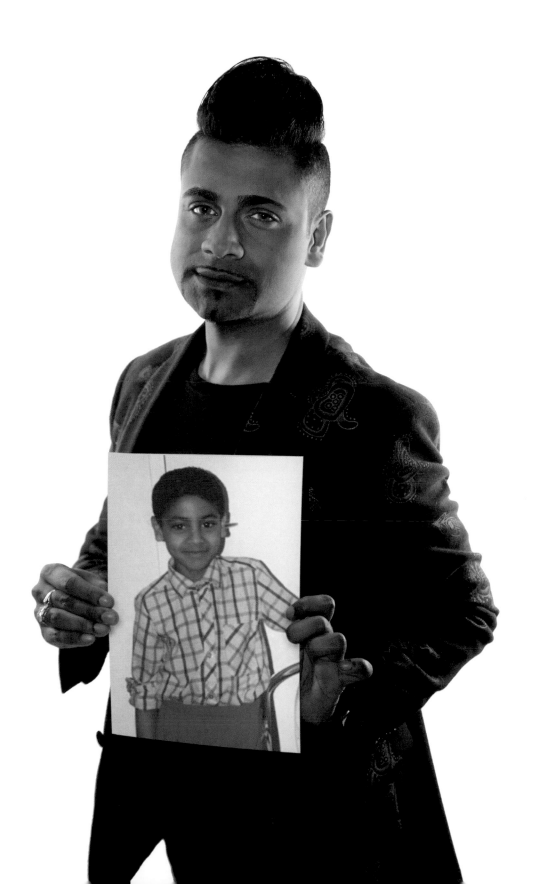

Cherry Potts
Author and publisher at Arachne Press

I came out as a lesbian when I was nineteen, in the heady days of 1980s feminism, and did a lot of shouting and fist-waving back then. I've calmed down (a bit).

I've always written, but started taking it seriously when faced with the dearth of cheerful lesbian novels in the 1980s. I'm onto my third book – I write slowly.

I told my school careers advisor I wanted to be a publisher, to which the response was, *why not be a librarian?* Several careers later (including libraries!) I'm finally doing what I really want.

I'm married to the lovely Alix Adams, who has been my partner for over thirty years.

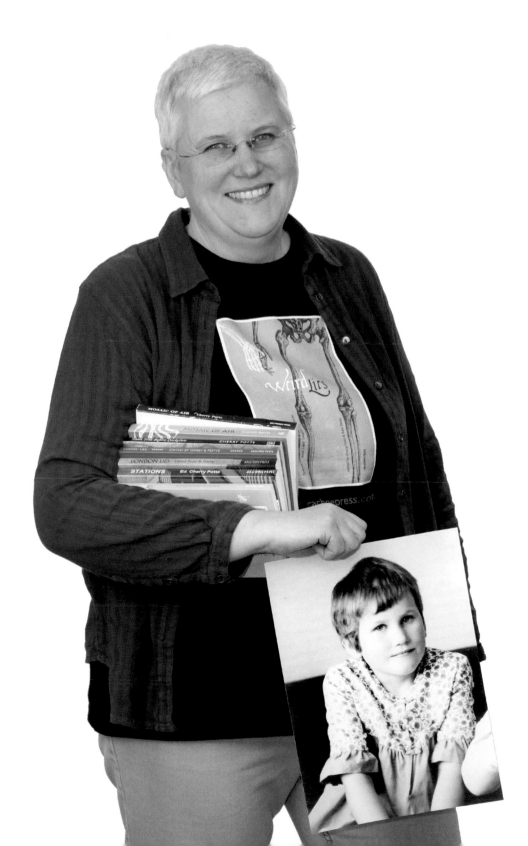

Andrew Moore
DJ

Scots-born Andrew first became professionally involved with dance music off the back of a filmmaking degree and subsequent role as cameraman and editor for Glasgow-based online electronic magazine eqtv.dj. Whilst there, he filmed and interviewed the likes of DJs Ben Klock, Jamie Jones, John Digweed, Art Department and Cajmere at Glasgow's club institutions Sub Club and The Arches, as well as filming in Leeds at Sven Väth's festival 'Cocoon In The Park' three years in a row and at Barcelona's Sonar festival.

Andrew moved to London in 2012, and has been building up an impressive club portfolio, hosting and promoting some of London's best-loved nights such as East Bloc's Dish and Handsome, Room Service and Beyond. He started DJing in 2014 at East Bloc's monthly Saturday club night BLOCHEADS where he became a resident as well as at Gymbox Bank and Victoria, and his own night Symposium, adding to his repertoire that also includes Dalston Superstore, Egg London, Shoreditch House, Home House, Shelter, top stores such as Cheap Monday, 'This Is Electric' Radio, Frost Festival, Macho Afterhours, Rumour Has It (Brighton) and Oceanbeat (Ibiza).

He spent Summer 2015 living and working in Ibiza where he had DJ gigs and worked for nights Glitterbox at Space and Decfected in the House's night Together at Amnesia.

Most recently Andrew has played at London, Madrid and Brighton Pride.

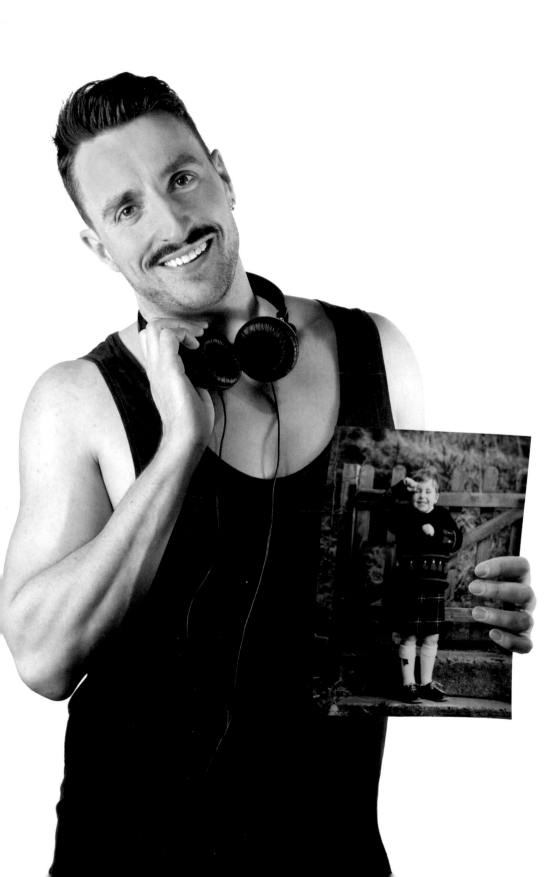

Jett Nyx (Tanith Nyx)
Author and poet

I have come out twice in my life, once as a lesbian (circa 1986) and again in 2016 as a FTM trans man. The baby photo of me in a pink dress probably shows the last time I allowed anyone to put me in a dress!

I am a writer and the speculative fiction novel I am currently preparing for publication features lesbians, a bisexual, two gay men and a genderqueer cat. I identify as Queer and proudly support the diversity of the LGBTQ spectrum.

I have a short story under the name Tanith Nyx, in the UK Lesfic anthology, *L is For*, with all proceeds going to the *RUComingOut* charity.

The world is my shellfish.

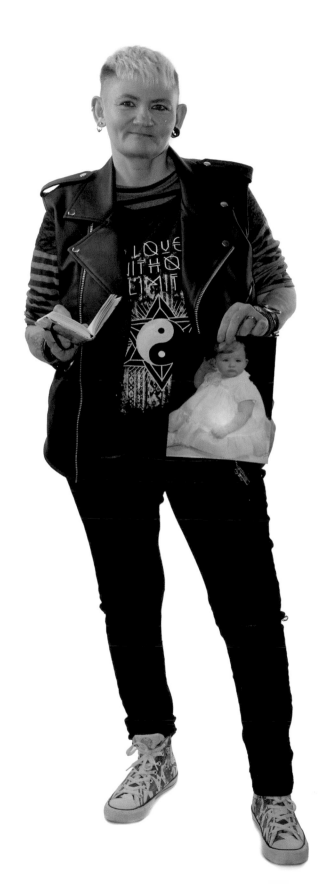

Andromeda Circus (Adrián Martel)
Aerialist, contortionist and fire performer

Andromeda Circus started dancing professionally at eighteen years of age for local tourist entertainment in Gran Canaria and soon he started touring Spain.

In 2000 he won the prestigious world-televised *Las Palmas de Gran Canaria Drag Queen Contest*, inspiring others by incorporating his circus skills into this creative art form. He then began touring Europe with his act involving fire and acrobatics.

In 2009 he joined Salvation Global Events, becoming the face of the brand and touring the globe with them. Chicago, Moscow, Berlin and many other major cities.

In 2011 he became a member of *Cirque Le Soir*'s international team, touring the world with them.

These days he is engaging crowds all over the globe in famous venues (VIP ROOM Paris, MANSION Miami, M1NT Shanghai), at the most prestigious events worldwide (Cannes Film Festival, Isle of MTV Malta, Milan Fashion Week, European Gay Ski Week) and has shared the stage with some of the biggest names in music (will.i.am, David Guetta, Calvin Harris).

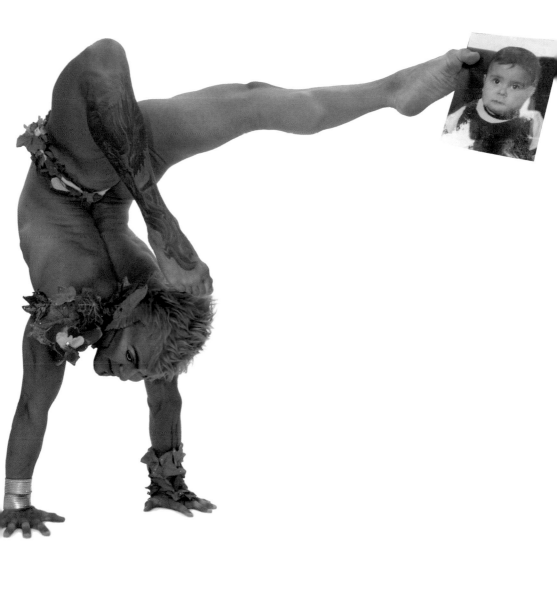

Helen Oakleigh
Actor, writer, human rights activist, film-maker and poet.

Helen Oakleigh's work has taken her around the world from the USA to The Middle East to almost every town and city in the UK. She has raised thousands of pounds for a range of charities and would love to see more equality in the world – this forms the basis of much of her more recent work. She also just about manages to find time to still play hockey.

'It is a terrible thing to hate love.'

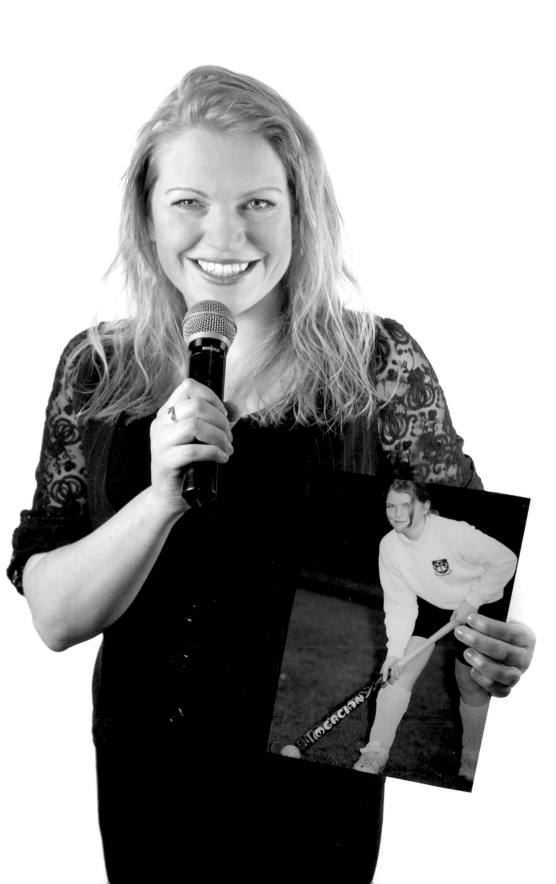

Daniel James Beeson
Head of engagement, *Gay Star News*

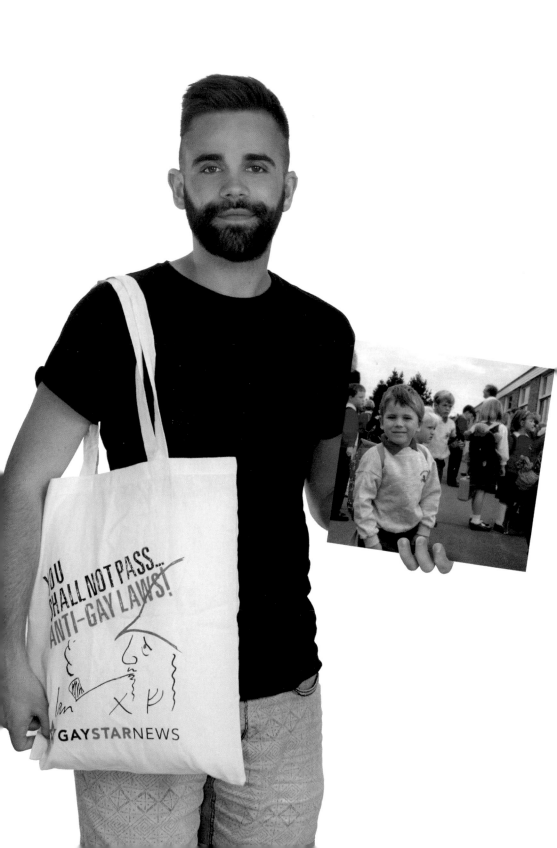

DJ Ritu

Globe-trotting DJ, broadcaster, and club promoter.

I began DJing in 1986 at the much-missed London Lesbian and Gay Centre. It was a hobby back then but now 30 years on I'm still at it!

I'm still a Motown, disco, and 80s diva but also a 'world music' specialist via radio, festivals, and gigs across the globe.

My show, 'A World In London' can be heard at Resonance 104.4fm and on Mixcloud, iTunes, and DAB and I'm on the decks at Luscious, Club Kali and various other nocturnal hotspots.

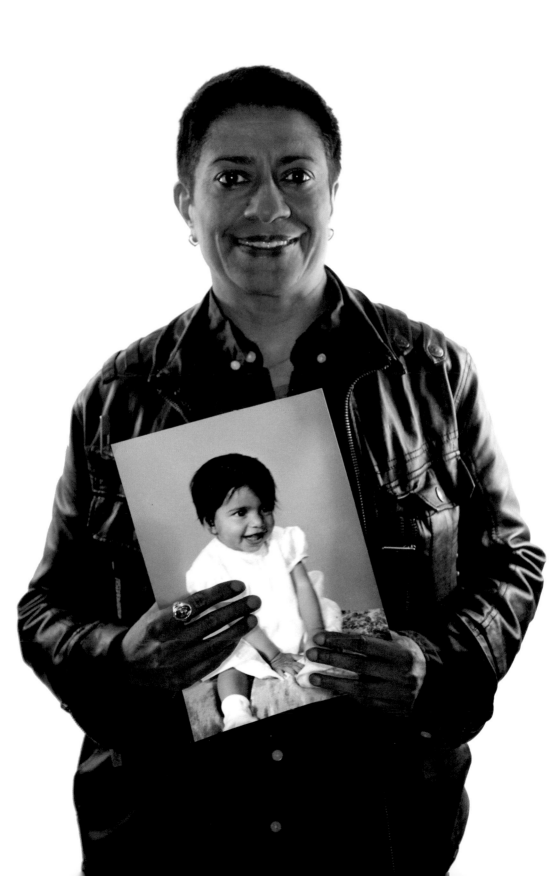

Jamie Raines
Participant in Channel 4's *Trans* series

I'm a University research student, focusing on the behavioural development and well-being of transgender people. My main hobbies are drawing (particularly digital art), and making YouTube videos. I came out when I was seventeen over the summer between my first and second year at college.

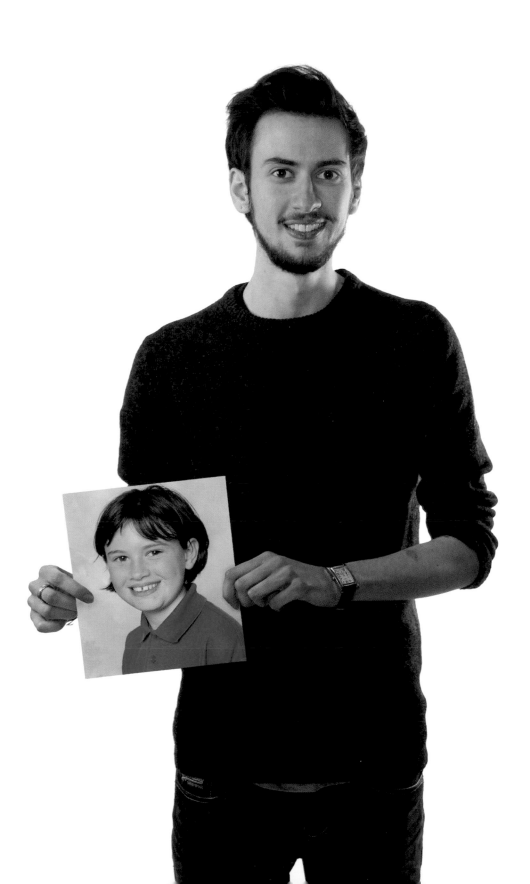

Susan Hailes

Lewisham LGBT liaison officer for London Met.

I came out as gay at age fourteen, back when Section 28 was still a thing, to some close friends at school. This information circulated quickly to the majority of the school I was attending in 1991. I am thankful to a small group of friends and a few supportive teachers who did their best to protect me from the insults, bullying and physical assaults I experienced. The teachers in particular risked their jobs to prevent the anti-bullying procedures at school from 'informing' my parents I was being bullied and thereby 'outing' me against my wishes.

I worked at an Arts newspaper for eleven years and then found myself, somewhat surprisingly, joining the police. I soon discovered that time hadn't changed much for many LGBT people and despite the wonders of the internet and gay bars, it was still hard to find the right support when people needed it. I volunteered as an LGBT liaison officer alongside my role as a Response Team Officer, offering referrals and information about what support was available locally and encouraging people to report all the homophobic/biphobic and transphobic incidents that so many of us think are a fact of daily life. I'm now on the Partnership Team working with the community and have more time to commit to supporting LGBTQ individuals in Lewisham and encouraging them to become a real community.

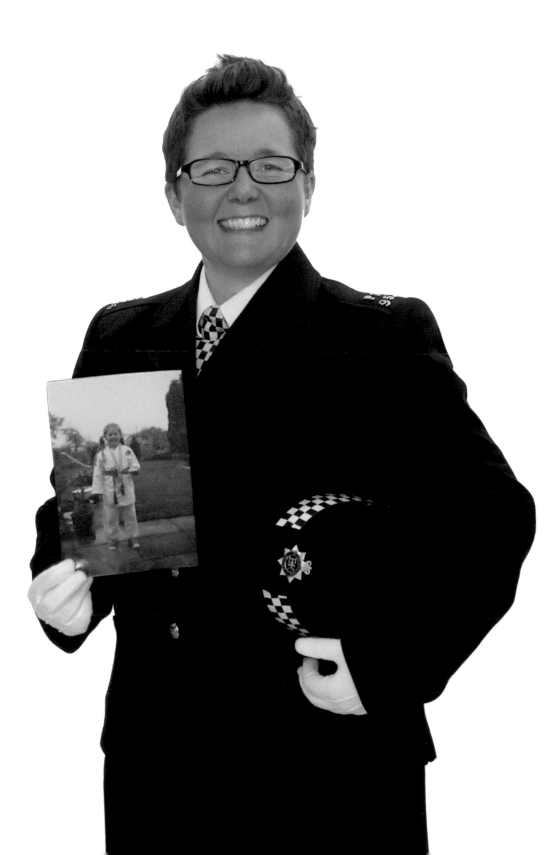

Martin Cremin

Swimmer for Scotland and Team GB at the Commonwealth Games

From Dunblane, Martin competed in 1500m freestyle at the 2014 Commonwealth Games. Former Scottish and French champion in that event as well as British universities champion, he represented Great Britain internationally in both pool and open water competitions before retiring from sport aged twenty-two.

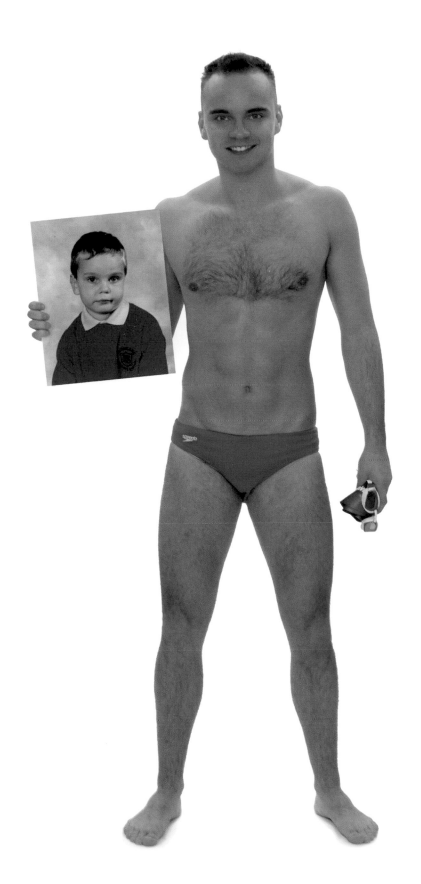

Rosie Wilby
Comedian, writer and broadcaster

Rosie has appeared many times on Radio 4 and at major festivals all across the UK – and even one or two in Sydney and New York with various shows including her award winning *The Science of Sex*. Her book, *Is Monogamy Dead?* comes out via Accent Press in 2017, and she presents the award-winning LGBT magazine show *Out In South London* on Resonance FM. She grew up in Lancashire and came out in her late teens before moving to London to discover gay life in the early 1990s.

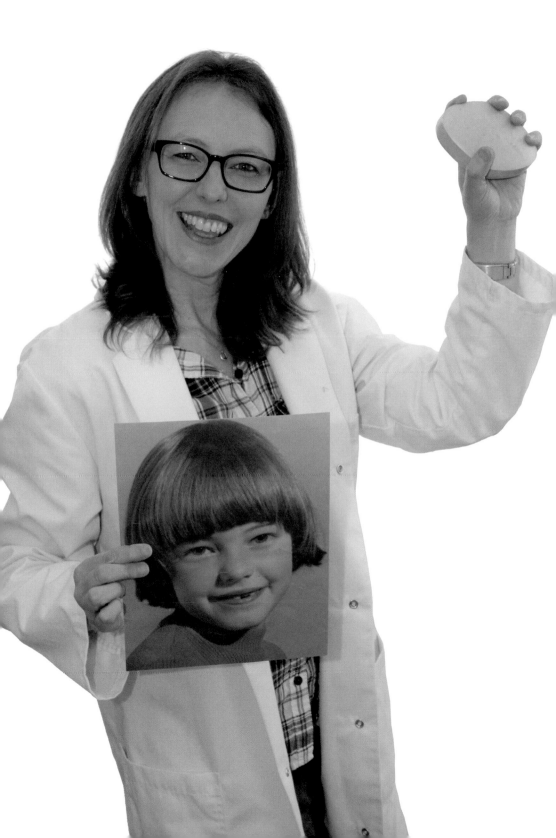

Marlon Kameka

Actor, director, playwright, choreographer, dancer, model and singer.

Since graduating in 2008, with a Degree In Performing Arts from London Metropolitan University, Marlon has taken part in an extensive range of performances from stage, film, television, online and site specific work.

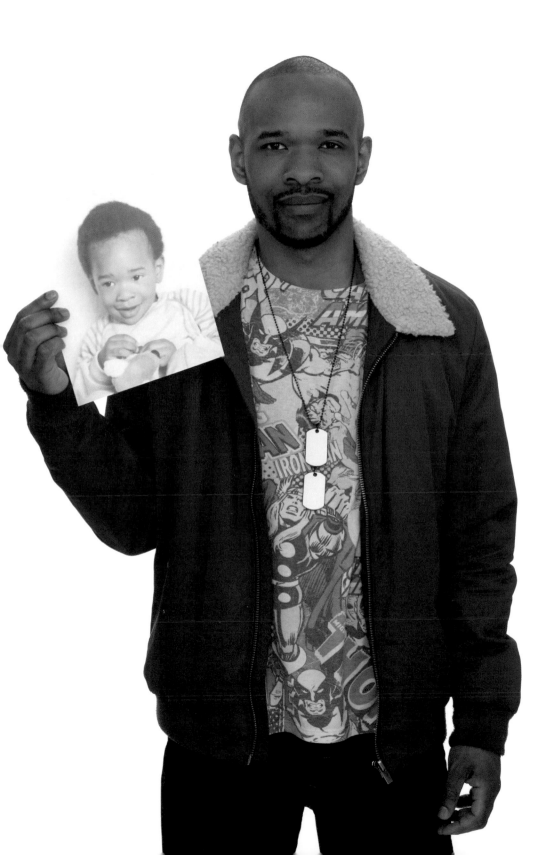

Amy Withnall
Photographer

I work as a home and community support worker with families of children with special needs. My main hobby is photography and last year I completed a BTEC (or Pearson I think it may now be called) level 2 in photography. I also love reading and I write book reviews for *Planet Nation*.

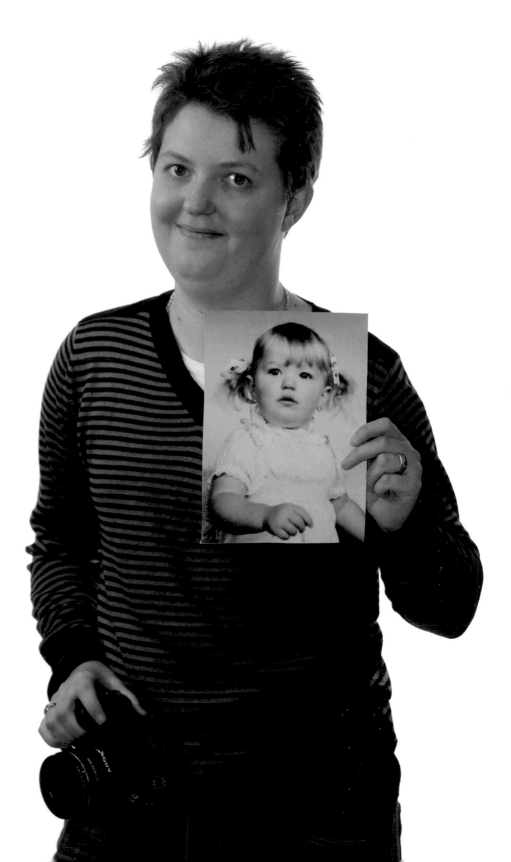

Mawaan Rizwan

Actor, writer and comedian

Mawaan shot to fame with the success of his YouTube channel (www.youtube.com/Mawaan), which has attracted over 20 million views and 90,000 subscribers.
Mawaan is a mischievous performer, with a no-holds-barred physicality and high-wattage charm – he studied clowning with world-renowned teacher Philippe Gaulier, whose alumni include Sacha Baron Cohen and Helena Bonham Carter. He has another BBC3 documentary in the pipeline and is returning to Edinburgh Fringe this year with his new surreal stand-up show *Gender Neutral Concubine Pirate*. He recently starred in BBC drama *Murdered By My Father* and fronted BBC3 documentary *How Gay Is Pakistan*.

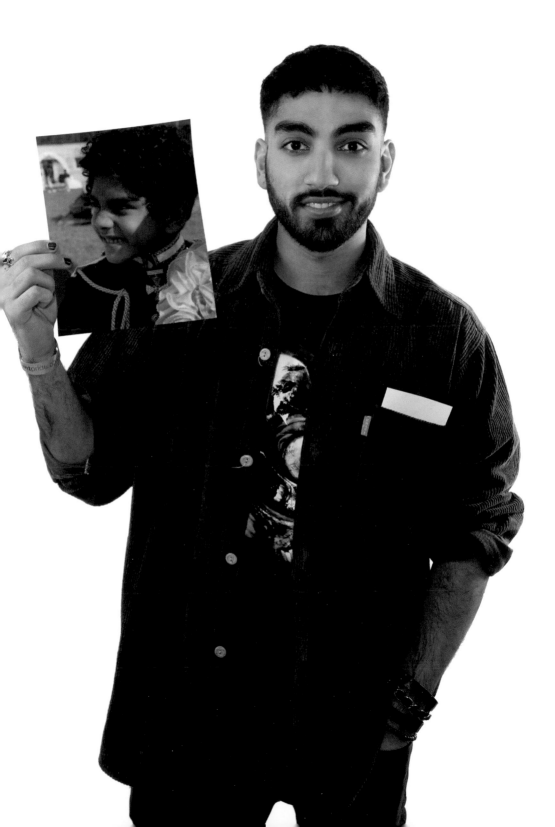

Jacq Applebee
Bisexual activist and writer

Jacq Applebee is a non-binary, disabled Londoner, a bisexual activist, writer, zinester and poet. They are the co-founder of the support and social group, *Bisexuals of Colour.*

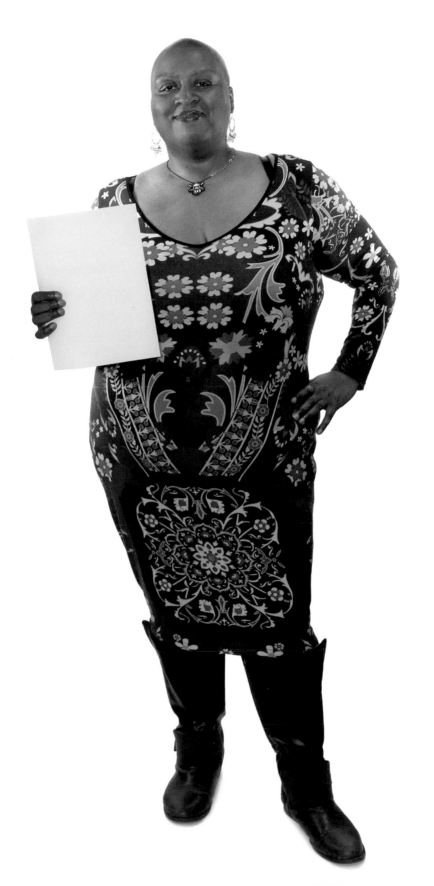

Neil Livingstone
Radiographer

I grew up in rural Australia where being gay was frowned upon. In the late 90s I moved away to Sydney for university and discovered a life for myself that wasn't as hostile as country Australia.
I've been a radiation therapist for sixteen years (thirteen of those in the UK) helping people living with cancer. When I return to visit my family in Australia, I notice how attitudes have changed and people have mellowed. This progress makes me smile.

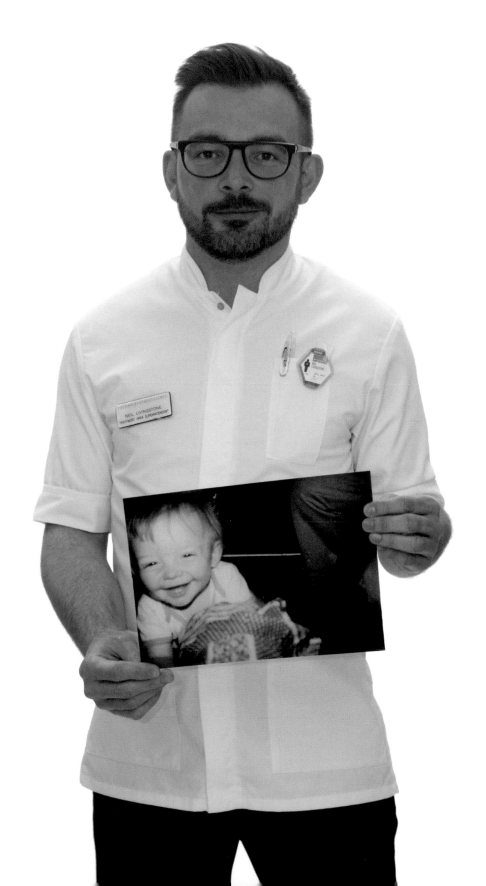

Heathen Jochens
Student

I am an International Relations student who loves to sing, write, watch YouTube, and drink tea.
I work in a library and a coffee shop.

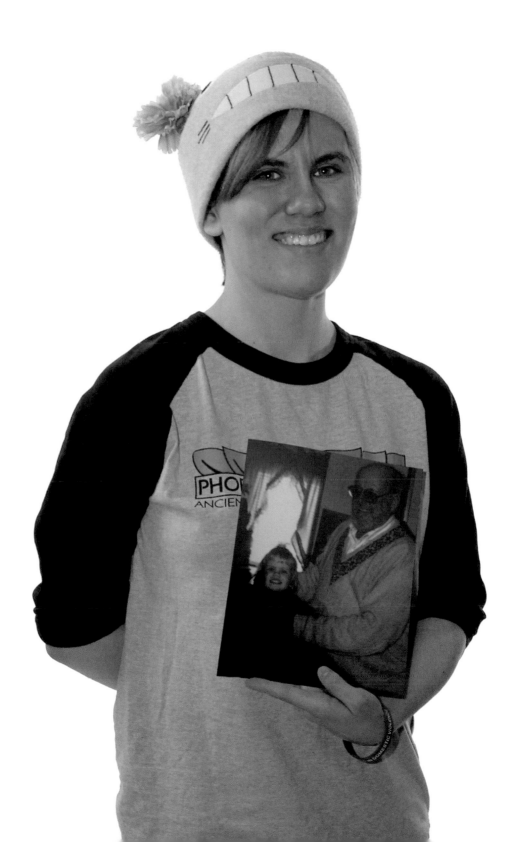

Freddie Martin
Tennis coach

When I was eight, I fell in love with tennis on a holiday in Marbella after I watched a local pro practicing at his club. Once home, I began lessons and further developed my love and passion for the sport. At the age of twelve, I started assisting with coaching sessions as my desires veered towards teaching. At seventeen, I became the youngest fully qualified Level 3 professional tennis coach at that time, and at twenty, I am now working at Pavilion And Avenue Lawn Tennis Club and also as the Sussex County Captain for the under-nine team. Tennis has been the fuel of my life for as long as I can remember and I can't imagine doing anything else!

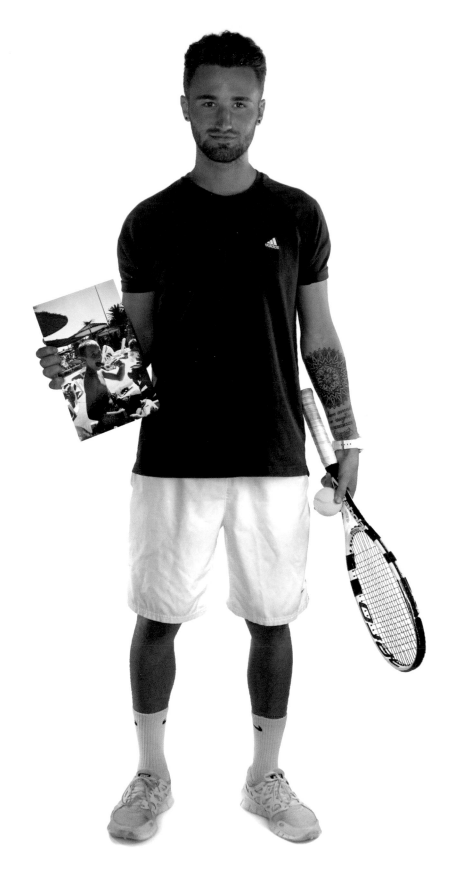

Nia Griffiths

Labour MP for Llanelli.
Shadow Secretary for Wales 2015-16

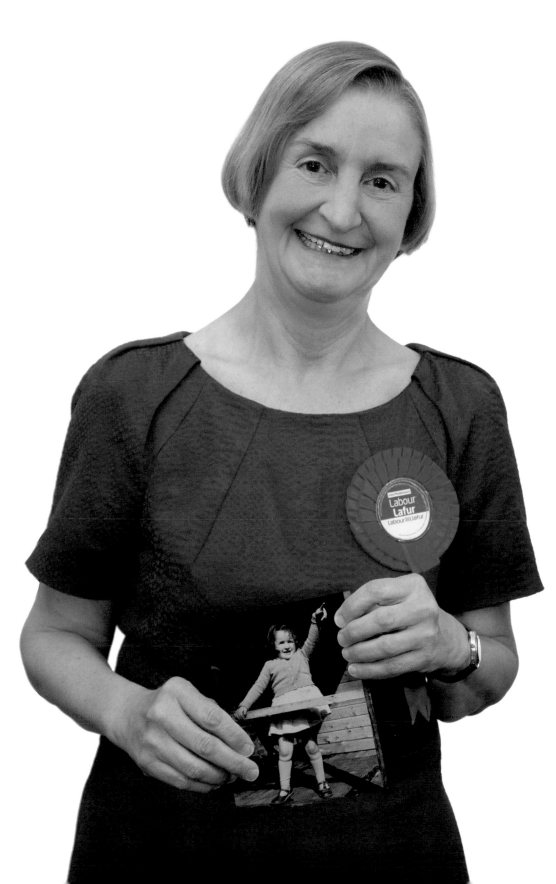

Bisi Alimi

Nigerian LGBT and HIV activist, fellow of the Aspen Institute.

Bisi was number 77 on the World Pride Power List 2014.
he is a LGBT/HIV advocate and public speaker and an international development consultant on sexual orientation and gender identity.

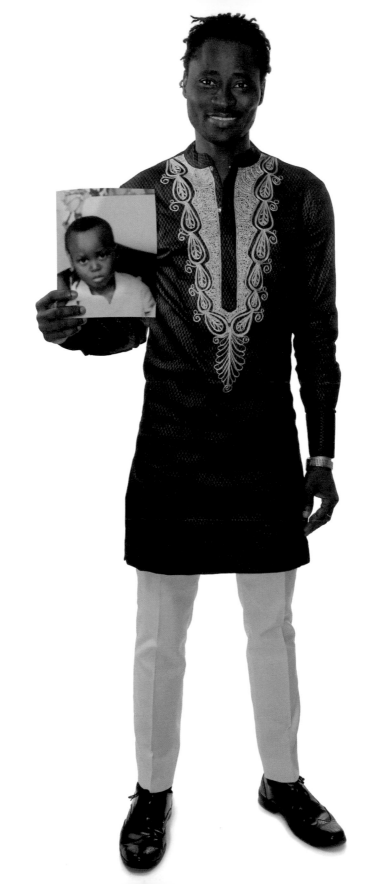

Jacqui Gavin
a:gender vice-chair

Jacqui joined the Civil Service in 2009 working for the DWP out of Warrington Pension Centre, after working her way up the career ladder in the private sector to head of service delivery for a major plc.

It was a decision that enabled Jacqui to combine her role as a respected transgender activist with working directly for transgender equality at the heart of government, as the first chair of the Transgender Network within DWP, then as an active steering group member of a:gender in 2010.

This was the launchpad needed as she became the vice chair of a:gender in 2012. In 2013 she became the youngest ever chair and in March 2015 returned as the vice chair.

This opportunity has allowed Jacqui to not only support the Civil Service in its delivery of transgender equality, but to work with external organisations to promote transgender equality across a wider landscape. This has highlighted to government the challenges of transgender people in their daily working lives, and enabled the equality gap between government and private industry to be narrowed.

Her dedication has been recognised nationally: she was 'Highly Commended' at the 2015 Excellence in Diversity Awards and was listed as the 44th most influential LGBTI person in the UK in *The Independent on Sunday* Rainbow List. Recently Jacqui was awarded the Diversity Champion Award at the 2016 British LGBT Awards.

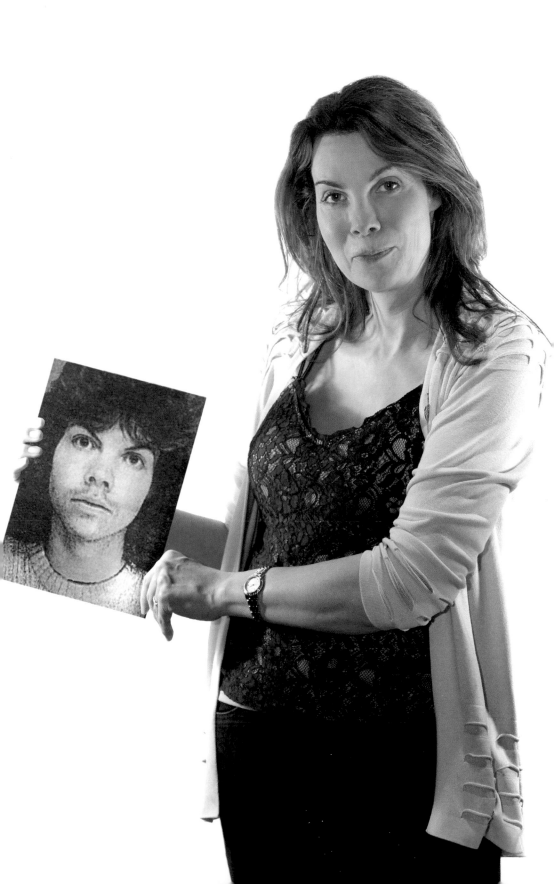

Richard Walker
Airline captain

I came out to my family and friends in 1993 at the age of twenty-one.

A few years later when joining my first airline, I did have some concerns about whether colleagues on the flight-deck would be accepting of me. I needn't have worried and have never looked back. I found a diverse, open and accepting industry through which I have enjoyed strong working relationships and made many good friends. I'm married to Ben who has been my partner for the last twelve years.

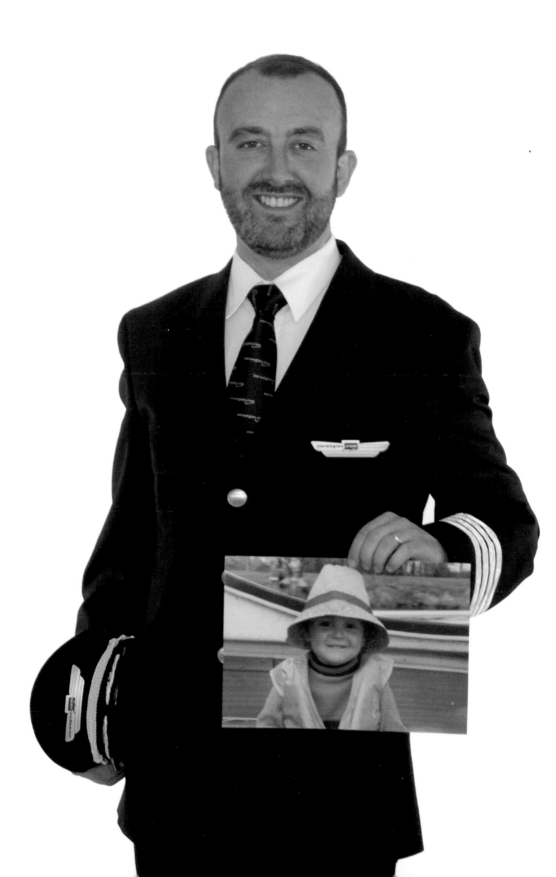

Kayza Rose
Head of media production – UK Black Pride

Kayza Rose is a photographer, film/TV producer and co-founder of BlackOutLDN – an organisation created in 2015 to support victims and take action against oppression suffered by POC. Using creative outlets to give marginalised groups a voice is her passion. After being chief of operations at a popular platform for LGBT artists, she now manages two talented musicians. Always keen to get involved in new and challenging projects, Kayza works closely with a variety of organisations.

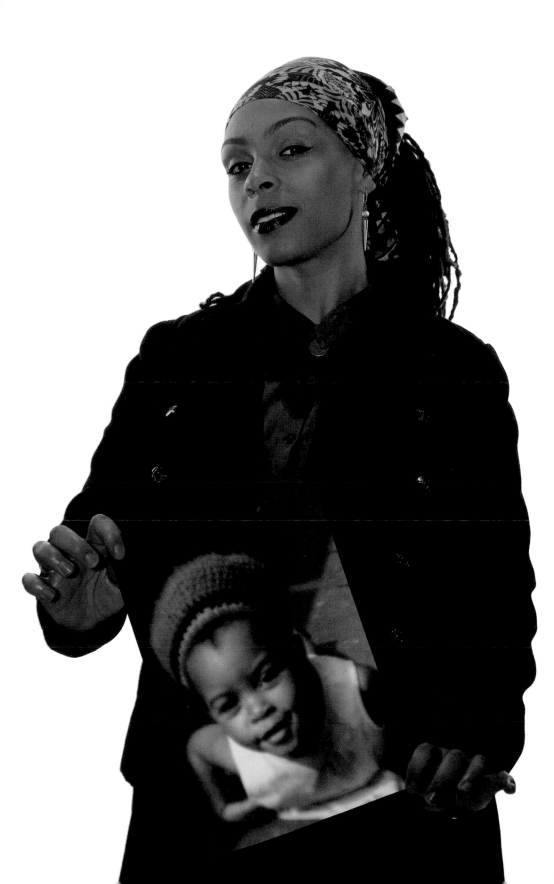

Harrie Brom
London Gay Men's Chorus member

I hail from Utrecht in the Netherlands. I moved to London ten years ago and still love the city and the people. I joined the London Gay Men's Chorus (LGMC) in 2010 and they have been my extended family ever since.

Amazing shows and small gigs in venues like Cadogan Hall, Southbank Centre and Hackney Empire, tours to Warsaw, Prague, Dublin and throughout the UK, film and CD/DVD recordings and taking part in the London 2012 Paralympics opening ceremony and an Anya Hindmarch fashion show are just a few of the many highlights I've enjoyed with the chorus over the years. They are my Band of Brothers.

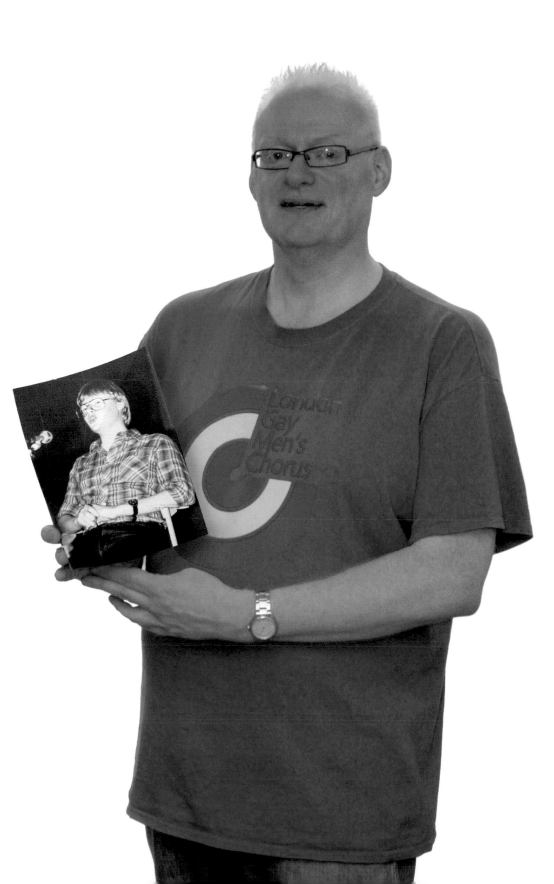

Kathryn Barnes and **Eleanor Fletcher**
Primary school teacher and undergraduate

Kathryn – I've been a primary school teacher for 7 years. Although I get incredibly frustrated at the education system sometimes, I do love seeing how open and tolerant kids are – it gives me hope for the world. Half my life is spent on trains, it seems, as Eleanor and I have been varying degrees of long-distance for the last two years!

Eleanor – I'm currently a student. Growing up in Devon meant I came out once, was met with homophobia, so moved schools and went back into the closet. I then came out after going to Pride in Birmingham and realised that being gay wasn't awful or anything to be ashamed of and even met my lovely girlfriend Kathryn. I now live in London where I enjoy the thriving gay scene and have never looked back! I have even performed at a gay bar in drag which was so liberating. While there's still a way to go, we have come so far and I have so much hope for the future of the queer community.

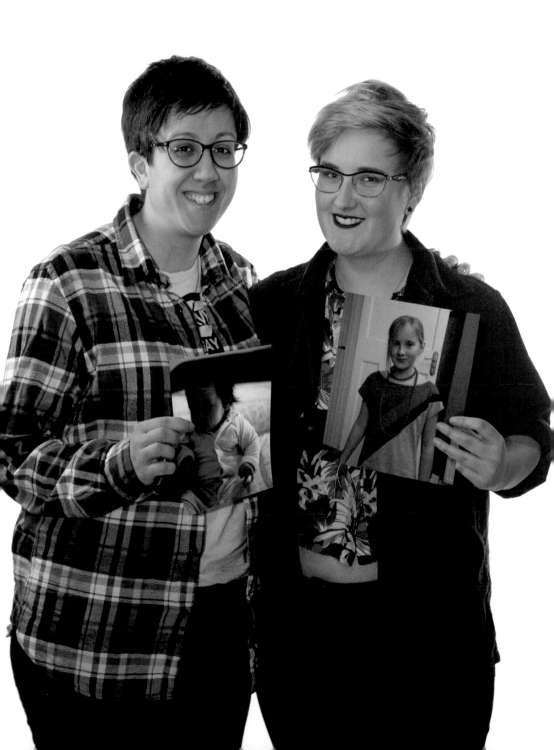

Michael Perry
Plant geek and TV presenter

A 'modern gardener' with a refreshingly relaxed and approachable attitude towards gardening, Michael inspires a 'have a go' philosophy to any horticulture dream, making home gardening as simple as possible. He challenges gardening rules and traditions and seeks out innovative ways to use new breeds of plants to create gardens.

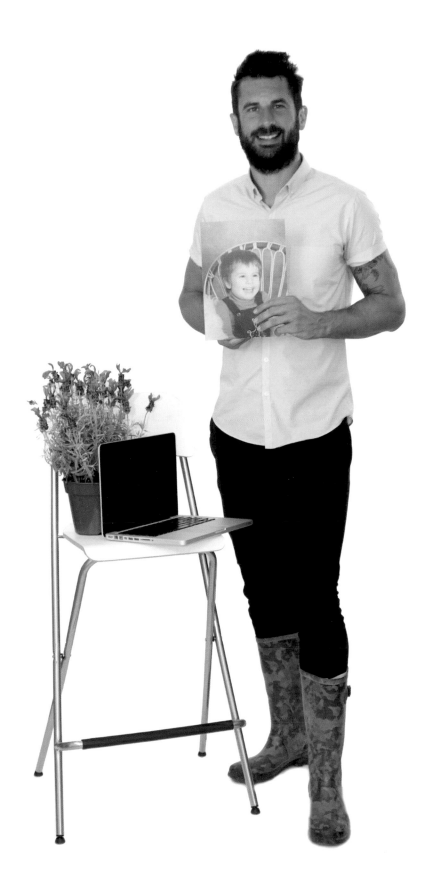

Pete Twyman
Yogi

Coming out and growing up was a difficult process, although I didn't want for a loving and supportive family. I was stuck between worlds and didn't know where to go. I ended up in a dangerous cycle of hedonism and self-loathing, searching for a great many things that didn't exist. Through the fog Yoga helped me find somewhere else to focus my energy, and let me find my voice. Because of what I learned I have been able to calm down and settle down. I have found who was underneath the masks all along, although the journey is never really complete.

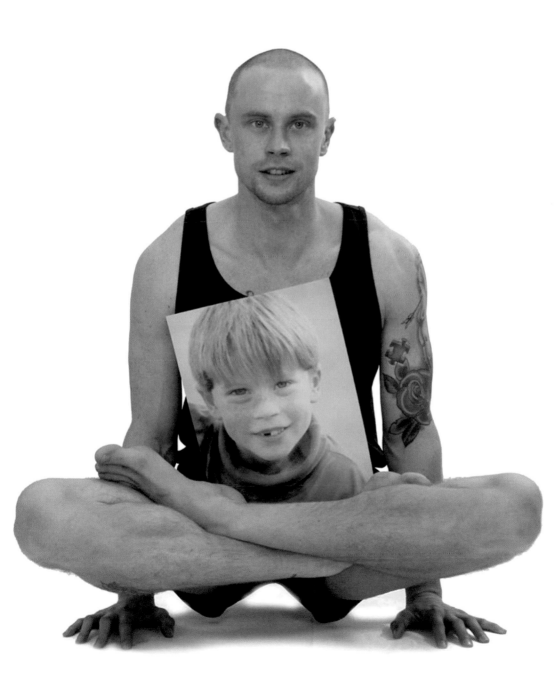

Kathy Caton
Brighton Radio Reverb host.

I present Brighton's award-winning LGBTQ radio show, *Out In Brighton*, on RadioReverb 97.2fm. I had the misfortune of going to school during Section 28 days which really influenced my younger life, and is one of the reasons I'm dedicated to getting voices and stories on air that simply aren't given proper space or time elsewhere – I firmly believe in being the change you want to see. I ran the Brighton Trans*formed project, preserving and documenting the oral histories of Brighton's trans community, and have had the privilege of interviewing literally hundreds of LGBTQ people over the years and getting their stories heard. In 2014 I founded *Brighton Gin* – I'm a Brighton obsessive – which I think you can hear in the *Out In Brighton* show!

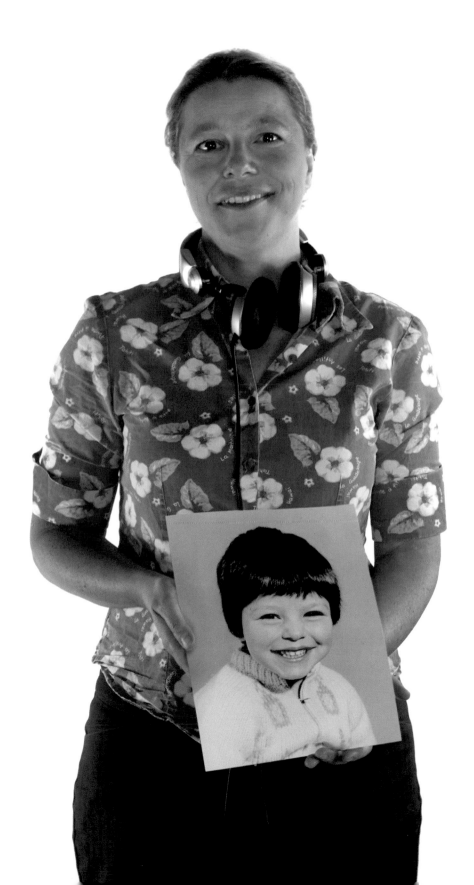

Robert Gray
B&B owner

I think I knew I was gay before I met Coco the Clown (pictured) in the 60s, I was an early developer.

I spent nine years at boarding school and then trained at Guildford School of Acting, and acted non-stop for ten years.

The next phase of my life started with selling antique teddy bears on Covent Garden market, and ended up with a freehold antiques shop on the Kings Road, Chelsea.

I am now the proprietor of my own guest house, 'number 16' in Greenwich, made famous by a popular episode of The Hotel Inspector, in which I was outed in the first ten minutes by the indomitable Ruth Watson.

I can occasionally be seen acting as myself on TV, including in my chat show, *Robert's Full English Breakfast* – available on YouTube if you are curious!

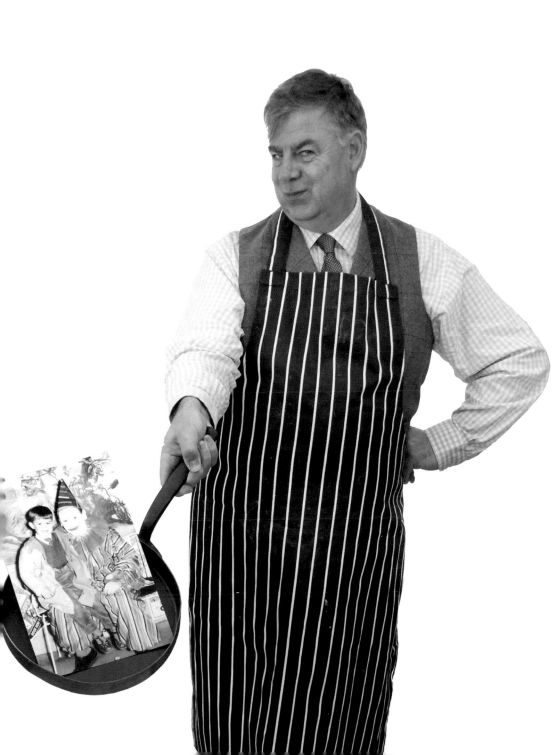

Femi Otitoju
Equality campaigner and consultant

Femi Otitoju was born in Nigeria, and raised in Worthing and London.
One of the UK's first out black lesbians, Femi describes herself as politically active and a bit of a sound bite queen. Femi has made a huge contribution to lesbian and gay equality over the last thirty years. Femi spends her days trying to make the world a better place to be lesbian or gay, in both her personal and professional lives. She says that is what she has always done. In the 1980's she was a volunteer on Switchboard and elected chair. She has also been on the management committees of the London Lesbian and Gay Centre, the Black Lesbian and Gay Centre and Stonewall Housing Association. In the 1986 she joined the staff of Haringey Council's Lesbian and Gay Unit – the first of its kind in the country and was a columnist for Capital Gay.
These days Femi continues to address heterosexism in her paid and unpaid work through her diversity and inclusion consultancy Challenge which she established in 1988 and in her position of co-chair of Women's Aid which she joined in 2013.
Femi says 'I am proud to be part of the Outcome project, we know that positive role models are vital in our continued battle for equality.'

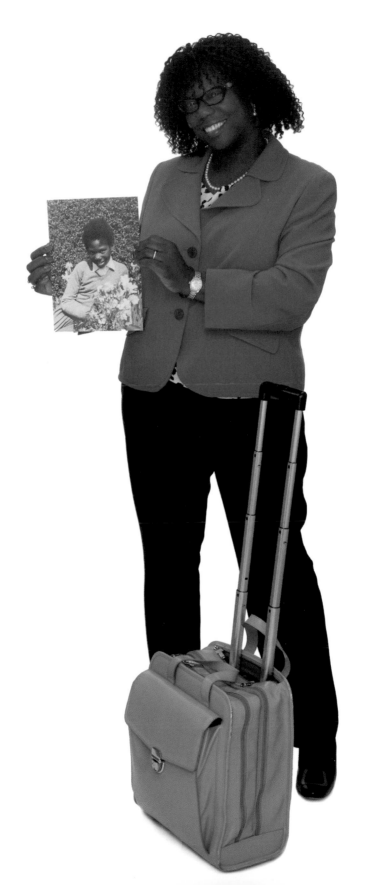

Lola Lasagne

The Brighton Belle! Singer of songs, teller of jokes; performing up and down the country.

Stephen Richards aka The Brighton Belle, Lola Lasagne, put his first stilettoed foot onto the stage of the Royal Vauxhall Tavern in June 1989 and hasn't looked back since.

Taking his drag persona across the UK and abroad, Stephen has shown off Lola in clubs, theatres and even television, where she was one of a select group of people who managed to get the last word against Anne Robinson on *The Weakest Link*!

Lola has been instrumental in Stephen developing his performing skills which helped make the transition from drag queen to pantomime dame, straight actor and stand-up comic.

Away from performing, Stephen and Lola have worked tirelessly for LGBT charities and organisations across the UK and especially in his hometown, Brighton, most notably Brighton Pride and Brighton's Rainbow Fund.

'All the world's a stage' and Stephen and Lola love the one they live in!

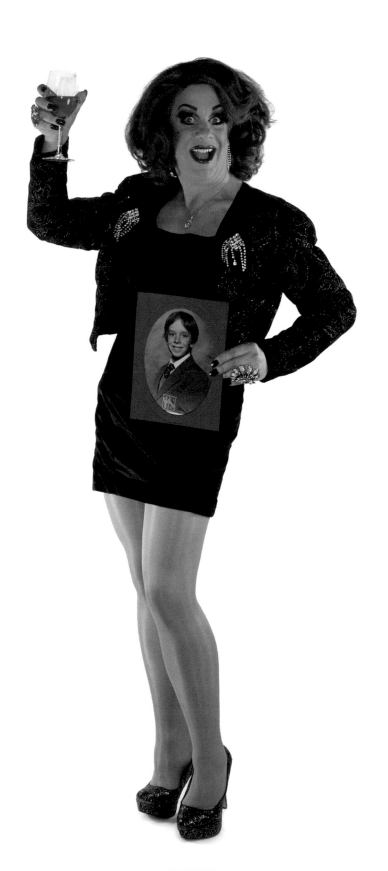

Bea Duval
Primary school music teacher

I always knew I wanted to be a music teacher. I loved music as a youngster and now I'm lucky that I am doing my dream job and getting to be musical with children every day.

It took me a while to accept for myself that I was gay, even though my friends and family told me it would be fine if I was! I didn't come out until I moved to London in my 20s. I met my wife eight years ago. We registered to be married on the first day we were able to and were married in the summer of 2014.

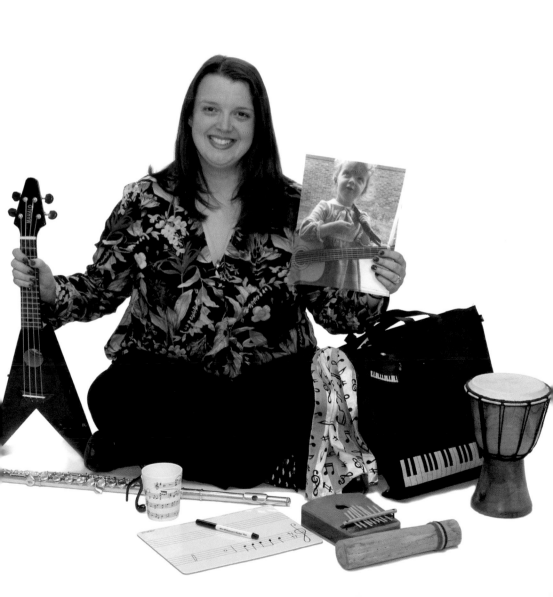

Lewis Hancox
Filmmaker, YouTuber, All About Trans ambassador and co-founder of My Genderation.

Kate Foley
Poet

Born in 1938 and adopted soon afterwards. The skinny girl you see in her childhood photo left school not very long afterwards with very few qualifications although she ended up with an honorary doctorate and her last day job was as the then English Heritage's Director of Science and Conservation. Coming out as a poet was the next step and Arachne Press has recently published her eighth book, *The Don't Touch Garden*.

As for *coming out*, it was attended by the usual Catholic guilt but was accomplished quite early and she has the good fortune to be married to Tonnie Bakkenist, who she met at a conference in Washington DC – as you do – and although Dutch is still a bit of a brain teaser for Kate, they live contentedly between Amsterdam and Suffolk.

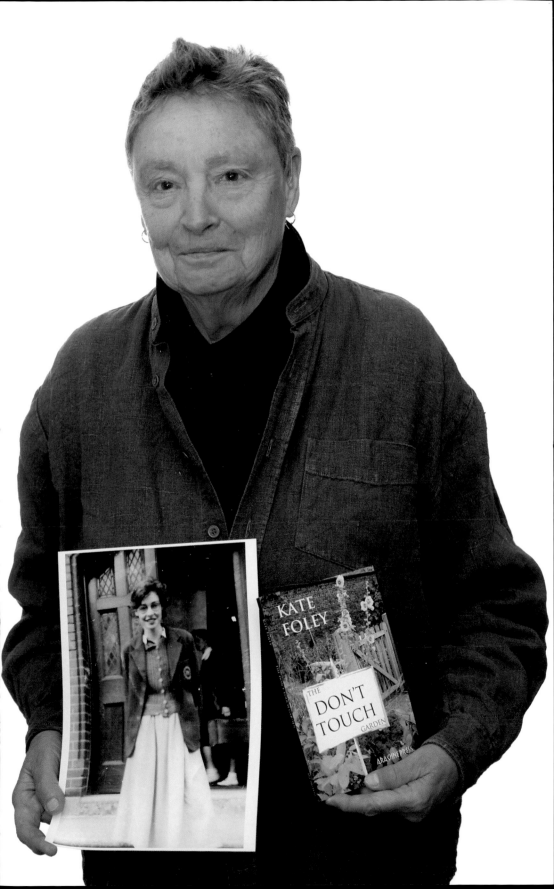

Matthew Kon
Runner with London Frontrunners

I work in higher education as a student advisor. I came out via a mass text to all my friends one evening when I was seventeen. I'm not yet twenty-five and it's never been a problem which I'm lucky to be able to say.
I'm thankful for the people who've fought and are continuing to fight for rights which I've acquired — I think it's important we continue to do the same for anyone else in need.

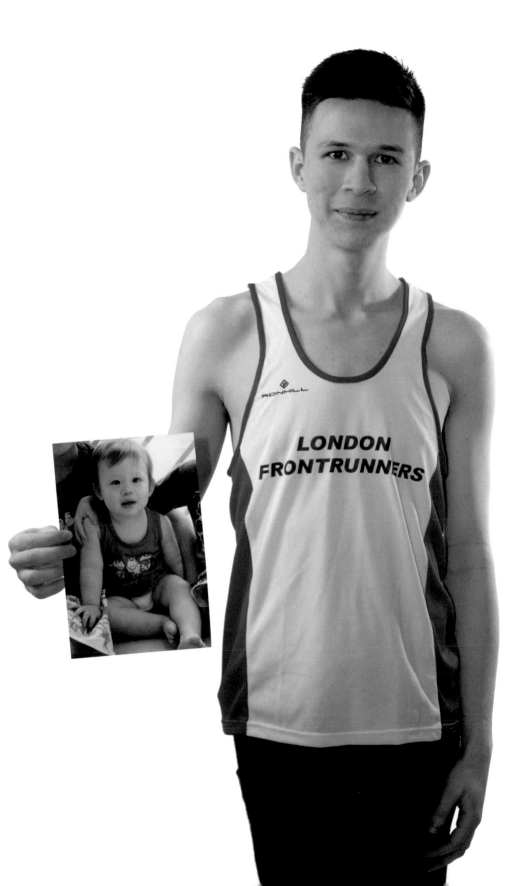

Elly Barnes MBE
CEO and founder of *Educate & Celebrate*

As a long-serving teacher, Elly developed her Best Practice Programme for schools and organisations focussing on training, policy, curriculum, environment and community from her own experiences of finding the most effective strategies to educate and change opinion.

'Increasing visibility around sexual orientation and gender Identity changes and saves lives. Our approach is preventative, proactive and accessible to all. We believe every conversation is important to move forward with breaking down the barriers to LGBT+ inclusion. Together, we can create cohesive school communities with people and social justice at its core.'

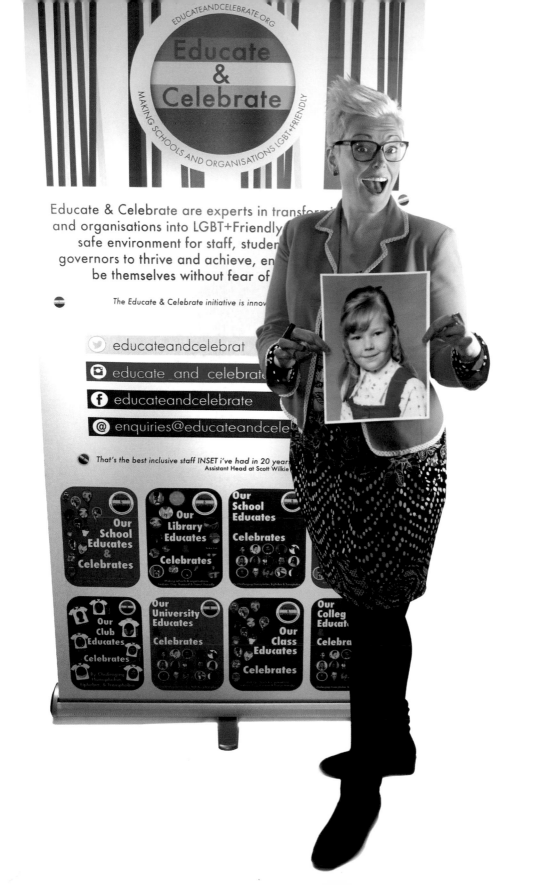

Tom Knight
Gay Times journalist and Pride in London producer

Tom Knight is a journalist for *Gay Times* Magazine and a regular on radio and TV.

He currently produces for Pride in London, Pride at Night and Pride in the Park.

Tom also plays a very active role in the LGBT+ community as an advocate, speaker and campaigner. As well as organising charity events such as his annual World AIDS Day fundraiser, he also raises funds for numerous charities such as GMFA, THT, AKT and many more.

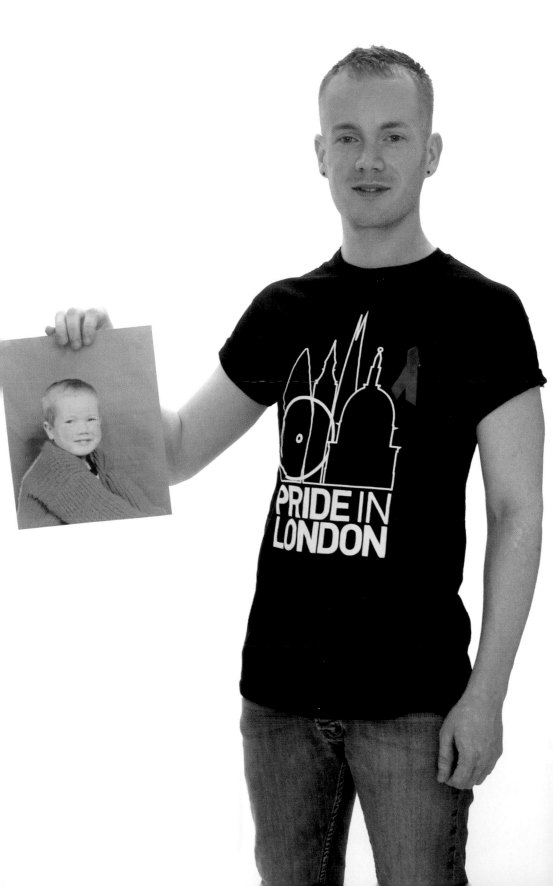

Amy Gunn (Terrible Ladygay)
Writer of blogs, articles and fiction of a smutty nature

I'm a theatre worker and writer from Sheffield. Notebooks are a huge part of my work so I chose to feature these in my photograph. I asked my mother to choose the image of myself as a child – I'm five and about to go to school. After this photo was taken I interviewed Tom about his project for an online magazine.

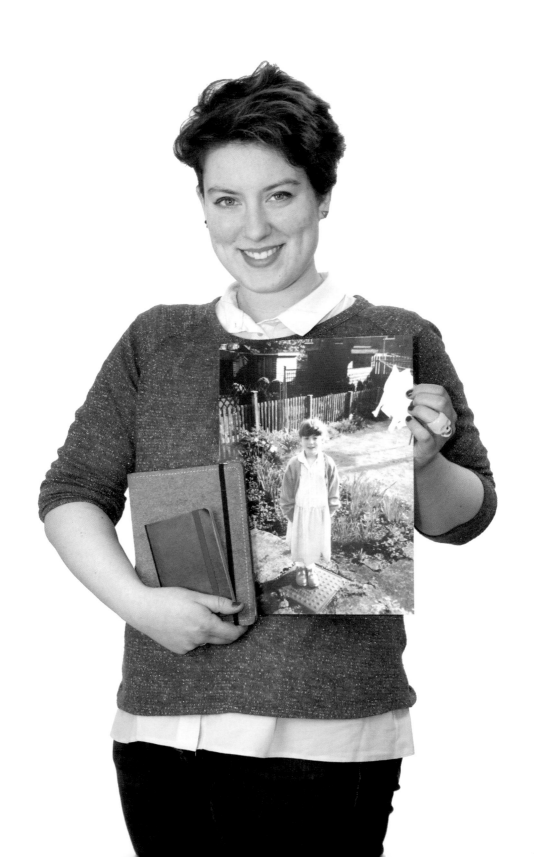

Peter Tatchell
Human rights and equality campaigner

Peter Tatchell has campaigned for LGBT and other human rights for forty-nine years, since 1967. His inspirations are Mahatma Gandhi, Sylvia Pankhurst, Martin Luther King and, to some extent, Malcolm X and Rosa Luxemburg.

Active in the London Gay Liberation Front from 1971-74, he staged the first gay rights protest in a communist country (East Germany, 1973).

He was the defeated Labour candidate in the 1983 Bermondsey by-election — the dirtiest, most homophobic and violent election in Britain for 100 years.

In 1989, he helped found the AIDS activist group ACT UP London, and in 1990 he was a founding member of the LGBT direct action organisation OutRage!

He outed 10 anti-gay bishops in 1994; twice attempted a citizen's arrest of the Zimbabwean dictator Robert Mugabe (1999 and 2001); interrupted the 1998 Easter Sermon of the then anti-LGBT equality Archbishop of Canterbury, George Carey; ambushed Tony Blair's motorcade in protest at the Iraq war (2003); and was beaten by neo-Nazis at the banned Moscow Pride parade in 2007.

He is Director of the Peter Tatchell Foundation:
www.PeterTatchellFoundation.org

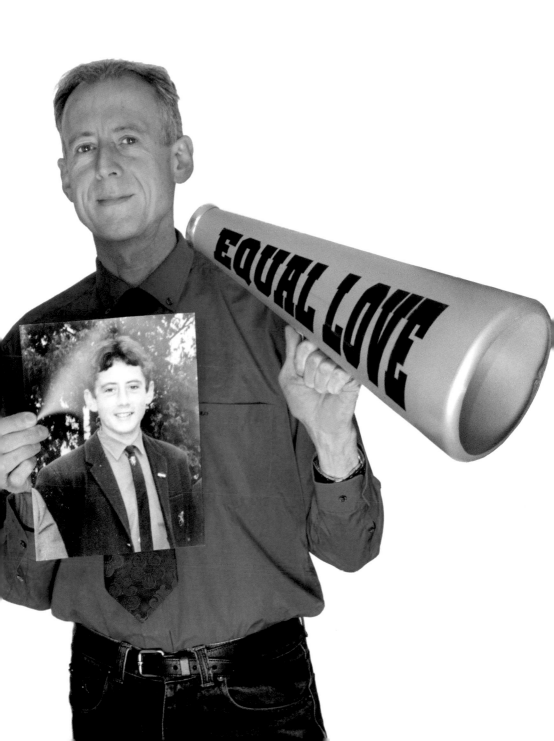

Naomi Bennett
Founder of Planet Nation

Naomi was born in Kent and moved in London about twelve years ago. She originally launched Planet London after several friends mentioned that there wasn't much on in London. Through forging relationships with promoters and LGBT entrepreneurs she has created a website that helps connect women with their community. Featuring a comprehensive events calendar and blog articles, in 2016 Planet London expanded to become Planet Nation.

In 2015 the website was shortlisted for a National Diversity Award in the category of LGBT Community Organisation, this came on the back of Naomi herself being shortlisted in the National Diversity Awards in 2014 as an Entrepreneur of Excellence.

Inspired by her love of her community, and wanting to help it to be as diverse as the women within it, she is always looking to collaborate and support as much as possible.

Naomi is supported by a team of Planeteers, women within the community who volunteer with the website. They are the heart and soul of Planet Nation.

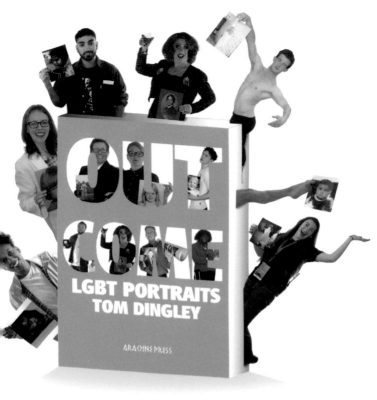

#OUTCOMEBOOK

LGBT Portraits by Tom Dingley
Exhibition & Book
Arachne Press

www.tomdingleyphotography.com
@OutcomeLGBT - @TomDingleyPhoto - @ArachnePress

#OUTCOME

Growing up. Coming out. Living life.

Cover image & portraits © Tom Dingley/ Cherry Potts.
www.tomdingleyphotography.com - @OutcomeLGBT - @ArachnePress

OUTCOME - LGBT Portraits
by Tom Dingley - ISBN: 978-1-909208-26-1

80 portraits of LGBT people with the attributes of their everyday life, and a photograph of themselves as a child.

Outcome Book available online and from Arachne Press - www.arachnepress.com/outcome

Exhibition continues at venues around the country
#Outcome - #OutcomeBook

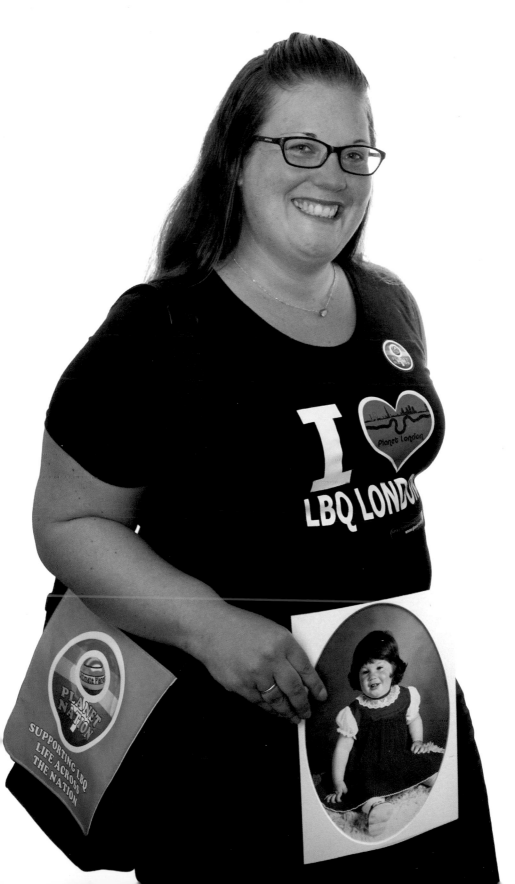

Peter Gracey
Engineer and marathon runner

I'm a 51-year-old railway signal engineer and an officer in the Royal Navy Reserve. I got into running a few years ago and since then I've run nine marathons. I only came out in 2009, the year before my first marathon. I guess I'd known I was gay for a long time, but I was married and had three kids.

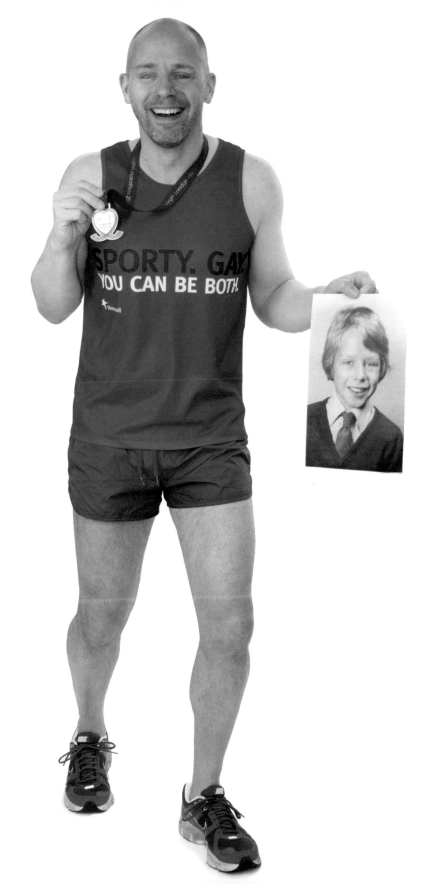

Vernon

Active committee member for Trans* Pride Brighton. Lover of all things vintage.

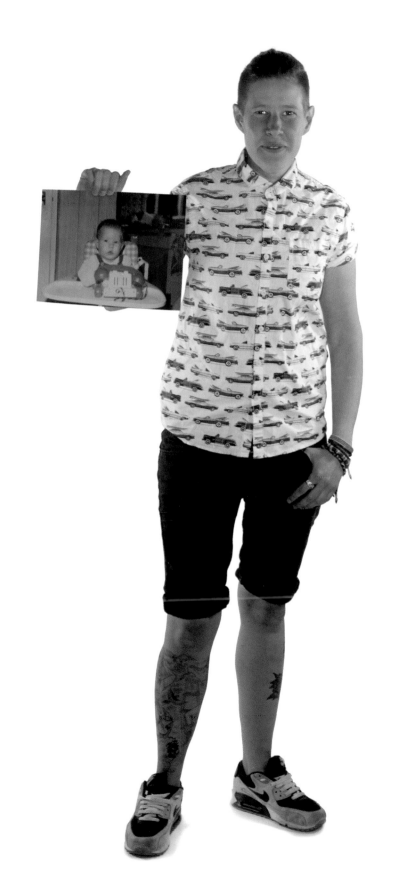

Luigi Ambrosio
Dancer and teacher

I am a 29-year-old, London-based dancer, currently studying choreography.

My story in the gay world is interesting for me. I actually became gay when I was twenty-one, after a night out dancing with work colleagues.

That morning waking up, I didn't know where I was, but looking beside me, I realised that the person next to me was my manager. Shocked, I didn't know what to think or what to do, so I went to the bathroom, crying tears of confusion and fear. At one point, looking at my reflection on the mirror I remember saying to myself, 'It's ok, there is nothing wrong with this, David Bowie did it too'. The days after were strange days. I was trying to refuse the possible idea of me being gay, I knew there always been something 'different' in me, but I wasn't sure if it was my sexuality. After that episode I took the risk and I started a relationship with my manager, even though, not knowing where I was standing... peacefully the answer came to me, 'I am GAY, but first of all I am ME', so I accepted the idea, embraced it. There is nothing wrong in being gay, we are people first.

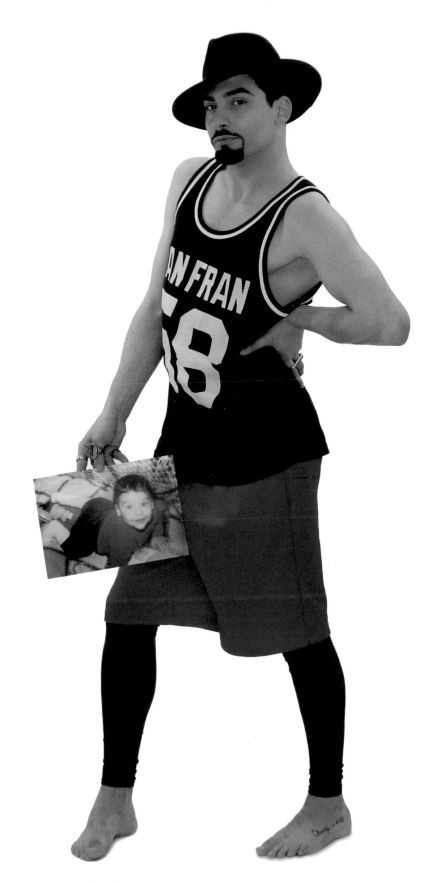

Sheila Wharton
Buddhist nun

I am a child of the 1950s — a long time before I heard the words *Lesbian* or *Buddhism*. With both I had to find my own way — a path that was sometimes difficult and perplexing — though never boring! As a child my play included being a nurse and a nun. Later I fell in love with the inspiring older girl who encouraged me to follow in her footsteps as a nurse and then a midwife, though, sadly, there was no encouragement in the way I fantasised being led by her!

Realising which side of the sexuality fence I belonged took a long time which, fortunately, gave me the space and time to have my beautiful son, Toby.

When I came out at fifty I had retrained to be a play therapist and social worker. Happily those professions are full of LGBTs and I had no difficulties at work.

Resolving the issues around my sexuality meant that I had space to explore other areas of my life. Buddhism made sense to me and recently those 'nun games' I played as a child came to fruition.

I'm aware that my late, easy entry into the world of Lesbians in 2000 was thanks to the bravery of my predecessors who fought so hard for our rights. Coming out at the age of fifteen in 1966 would have been a different story altogether.

My life has been amazing, sometimes hard, as I tried to 'find myself'. All I really needed to do was to have the confidence to stay true to myself.

I'm glad I am who I am.

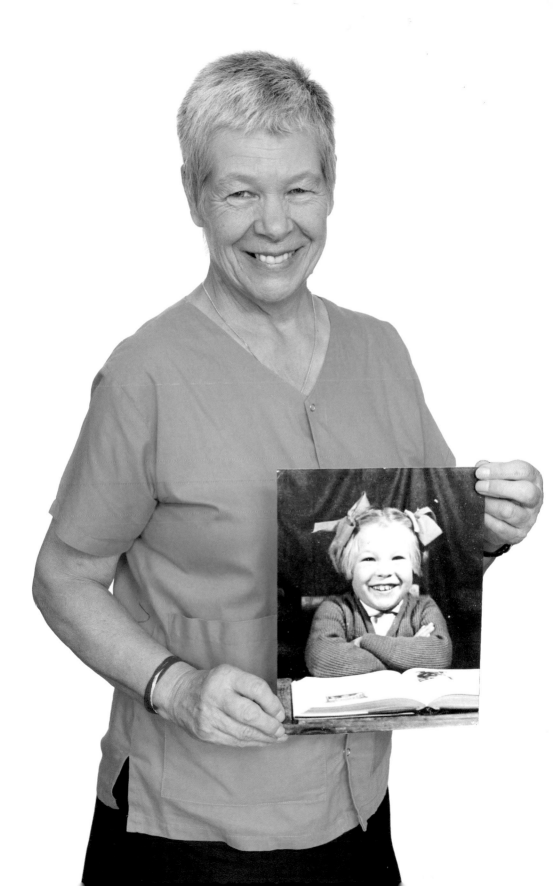

Jonathan Blake
Founding member of LGSM

Born in 1949, I am a medically retired, former actor, tailor, costume maker and gardener. I am aLong Term HIV Survivor , diagnosed Oct 1982 HTLV3, and a founding member of 'Lesbians and Gay Men Support The Miners' (LGSM).
I am happy that my HIV status was 'outed' to the world during the end credits of *PRIDE* the movie, as I hope it may help to normalise the disease and aid an end to stigma. As a character in the film, Jonathan was not a victim; HIV was just part of his DNA/RNA. I am not a victim. There is no stigma in being HIV+.

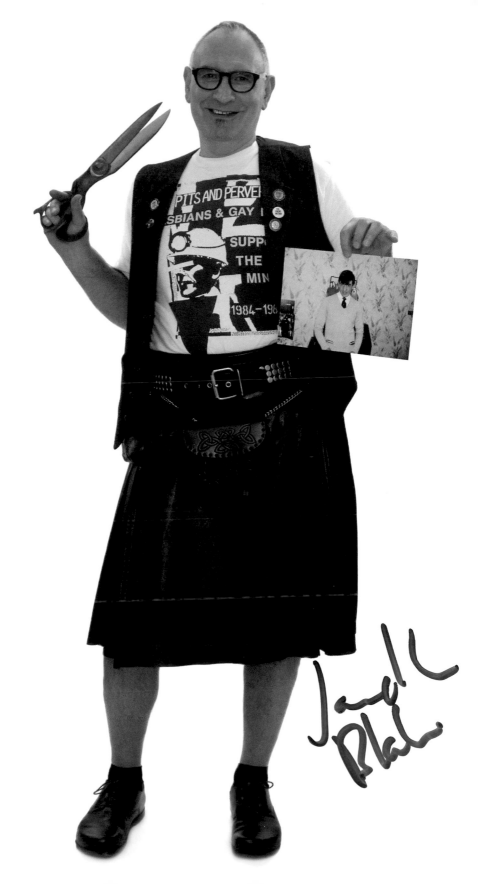

MORE FROM ARACHNE PRESS

www.arachnepress.com

EVENTS

Arachne Press loves live literature and we make an effort to present our books through readings. We showcase our work and that of others at our live literature event in south London: *The Story Sessions* (arachnepress.com/the-story-sessions/); and in 2014, we ran our first festival, *Solstice Shorts* (arachnepress. com/solstice-shorts/), now in its third year. We are always on the lookout for new places to show off, so if you run a bookshop, a festival or any other kind of literature venue, get in touch, we'd love to talk to you.

ARACHNE FRIENDS

Become a 'Friend' of Arachne Press and get special offers for a year, or for life! arachnepress.com/support-arachne-press/become-a-friend-of-arachne/
Follow us on twitter @arachnepress
Like us on Facebook https://www.facebook.com/ArachnePress

Selected BOOKS

By LGBT authors:
Mosaic of Air, Cherry Potts ISBN: 978-1-909208-03-2
The Dowry Blade, Cherry Potts ISBN: 979-1-909208-20-9
The Don't Touch Garden, Kate Foley ISBN: 978-1-909208-19-3
Nominees and winners of awards
Weird Lies ISBN: 978-1-909208-10-0
WINNER of the Saboteur2014 Best Anthology Award
Devilskein & Dearlove, Alex Smith ISBN: 978-1-909208-15-5
Nominated for the 2015 CILIP Carnegie Medal.